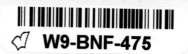

PENGUIN BOOKS

PICASSO ON ART

Dore Ashton is Professor of Art History at Cooper Union for the Advancement of Arts and Sciences in New York City. She has written extensively on modern art for journals and is the author of several books, among them *The New York School, Readings in Modern Art, A Joseph Cornell Album,* and *Yes, But . . . : A Critical Study of Philip Guston.*

The Documents of 20th-Century Art

The history of art has run a complex and often confusing course, and yet we still rely heavily on critics and historians to interpret for us the development of modern art and even the works themselves. Robert Motherwell, one of America's most distinguished artists and the originator of *Documents of 20th-Century Art,* believes that the writings of artists and their associates should be made available in English to enable students, artists, and general readers to study and understand the art of this country at its source.

ROBERT MOTHERWELL, *General Editor*

BERNARD KARPEL, *Documentary Editor*

ARTHUR A. COHEN, *Managing Editor*

Vallauris 26.12.53

Picasso on Art:
A Selection of Views

Dore Ashton

PENGUIN BOOKS

Penguin Books Ltd, Harmondsworth,
Middlesex, England
Penguin Books, 625 Madison Avenue,
New York, New York 10022, U.S.A.
Penguin Books Australia Ltd, Ringwood,
Victoria, Australia
Penguin Books Canada Limited, 2801 John Street,
Markham, Ontario, Canada L3R 1B4
Penguin Books (N.Z.) Ltd, 182–190 Wairau Road,
Auckland 10, New Zealand

First published in the United States of America
by The Viking Press 1972
Reprinted 1974
Published in Penguin Books 1977

LIBRARY OF CONGRESS CATALOGING IN PUBLICATION DATA
Picasso, Pablo, 1881–1973.
Picasso on art.
Bibliography: p.
1. Art—Addresses, essays, lectures. I. Title.
N7454.P52 1977 701 77-5626
ISBN 0 14 00.4528 7

Printed in the United States of America by
Halliday Lithograph, West Hanover, Massachusetts
Set in Linotype Times Roman

*The following pages constitute a continuation
of this copyright page.*

Acknowledgment is made to the following:

Harry N. Abrams, Inc.: From *The Artist and His Model*; *Women*; *Intimate Secrets of a Studio*, all by Hélène Parmelin; *Toros y Toreros* by Louis Dominguin.

George Allen & Unwin Ltd.: From *Picasso Says* by Hélène Parmelin.

Arts magazine: From André Warnod's interview with Picasso, from *Arts* edition of June 1945.

Arts de France: From *Midis avec Picasso* by Anatole Jakovsky, 1946.

The Burlington Magazine Publications Ltd. and Xavier de Salas: From *Some Notes on a Letter of Picasso* by Xavier de Salas.

Doubleday & Company, Inc.: From *Picasso and Company* by Brassaï, translated by Francis Price. Copyright © 1966 by Doubleday & Company, Inc. Reprinted by permission of the publisher.

Editions Gallimard: From *Conversations avec Picasso*, Brassaï. © Editions Gallimard 1964; from *L'Amour de la Peinture* by Claude Roy. © Editions Gallimard 1956.

Giangiacomo Feltrinelli S.p.A.: From *Scritti di Picasso* by Mario de Micheli. Copyright © Giangiacomo Feltrinelli Editore, 1964.

David Higham Associates, Ltd.: From *Picasso* by Gertrude Stein, published by Beacon Press.

Daniel-Henry Kahnweiler: From his interviews with Picasso.

Les Lettres Françaises: From "Picasso N'est pas Officier dans l'Armée française" by Simone Téry. March 24, 1945.

Lund Humphries Publishers Ltd.: From *Picasso in Antibes* by Dor de la Souchère.

The Museum of Modern Art, New York: "Statement by Picasso: 1923" from *Picasso: Fifty Years of His Art* by Alfred H. Barr, Jr., Copyright 1939, 1946 by The Museum of Modern Art, New York; "Statement by Picasso: 1935" from *Picasso: Fifty Years of His Art* by Alfred H. Barr, Jr., Copyright 1939, 1946 by The Museum of Modern Art, New York. All other material from *Picasso: Fifty Years of His Art* by Alfred H. Barr, Jr., Copyright 1946 by The Museum of Modern Art, New York, and reprinted with its permission.

Mrs. Louis Parrot: From Louis Parrot's interview with Picasso (*Masses and Mainstream*, March 1948).

viii / *Acknowledgments*

Prentice-Hall, Inc.: From *Picasso: An Intimate Portrait* by Jaime Sabartés.

Martin Secker & Warburg Ltd. and René Julliard: From *Picasso Plain* by Hélène Parmelin.

Jerome Seckler: For his interview with Picasso (March 13, 1945, issue of *New Masses*).

The Viking Press, Inc.: From *The Artist in His Studio* by Alexander Liberman. All rights reserved. Reprinted by permission.

This book is warmly dedicated to
ALFRED H. BARR, JR.

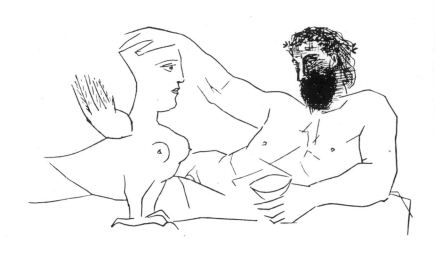

Author's Note

The scores of people who have helped me to winnow through the massive Picasso literature, and to discern the truths sometimes so well hidden, are hereby deeply thanked. Among those who gave their generous counsel I must first of all mention my friend the late Christian Zervos, who never failed to answer my inquiries and was always generous with his replies. I must especially thank Madame Hélène Parmelin, Roland Penrose, Michel Leiris, Douglas Cooper, Jean Leymarie, Daniel-Henry Kahnweiler, and Don Gustavo Gili for their generous attention to the problems I brought them. Also Georges Boudaille, Ernst Beyeler, James Thrall Soby, Pierre Daix, Dor de la Souchère, André Verdet, Madame Louis Parrot, Madame Louise Leiris, Manuel de Muga, and Alfred H. Barr.

Such a task could never have been completed without Bernard Karpel's enthusiastic help, and I owe much to the skillful guidance of Miss Inge Forslund in the Museum of Modern Art's library and Miss Riva Castleman in the Museum's Department of Prints. I want to thank Carolyn Betsch for her excellent editorial work, and Alejandro Gomez Marco, Melitta del Villar, Richard Howard, and Adja Yunkers for help with translations. All those who gave permission for their texts to be used are gratefully acknowledged. Finally, I want to thank Miss Barbara Burn, whose work as an editor was matchless.

Contents

IV

V

VI

VII

VIII

IX

X

XI

xvi / *Contents*

Introduction

Everyone who has ever had any extended concourse with Picasso agrees that the one subject to which he will not address himself in writing is art. In conversation, on the other hand, it is a subject which inspires him to vertiginous flights of irony. His intimate friends are unanimous in asserting that he never offers erudite discourse, but rather, brief paradoxes and swift witticisms. In his most serious conversations, which occur only with a few, usually very old friends, they report that his pithy observations defy transcription and that even they, who are accustomed to Picasso's utterance and can decode it, cannot record it in a way that shapes a definitive aesthetic.

Madame Hélène Parmelin, who according to many of Picasso's oldest friends comes closest to recording the tenor of his remarks, was once in his studio browsing through his sketchbooks and came across a rare written notation. She was struck by it because, as she says, Picasso writes letters, poems, plays, and talks all the time about painting, but he never writes about it. Never. His thoughts, she says, are "constantly transformed like his paintings." (The phrase which caught her attention was: "Painting is stronger than I am. It makes me do what it wishes.")

It is obvious that a book which purports to present Picasso's views on art is necessarily limited, since it is always dependent on the sensitivity and intelligence of those who are recording his conversation. They are reporting what they heard, and, in some cases, what they *think* they heard. Christian Zervos, one of Picasso's oldest friends and critics, has often said that Picasso speaks seriously with very few friends, and not even with them when there are other people around. "When there are a lot of visitors, he jokes; he plays the clown" (conversation with the author, June 1969). Such clowning is certainly a form of self-defense, for Picasso has been the victim of

more misunderstanding and distortion than any other twentieth-century artist. "I have often heard him raging like a devil in a holy-water font against the sayings they attribute to him which make him seem ridiculous or primitive—something which Picasso definitely is not!" Zervos says (letter to the author, March 11, 1969).

From the beginning Picasso was always wary of aesthetic pronunciamento, and always terse or epigrammatic. When Maurice Raynal wrote one of the first full accounts of the early Paris years, he noted that "Picasso never propounded theories. Those who, like me, saw him often, remember perhaps a few incisive words; immediate confirmations of his work in progress, but that's all" (*Picasso*, Edition G. Grès & Cie, 1922).

Old friends consistently support Raynal's observation. The poet and ethnologist Michel Leiris says that Picasso speaks invariably "in quick flashes of insight and wit." He is capable of going to surprising depths with a great range of references to things such as chemistry or physics, Leiris says, and he can also explain things very simply, "like an artisan." But it is never possible to record his conversation precisely: "The *occasion* is always very important." To take his remarks out of their rich context is to falsify the quality of Picasso's mind, he feels (interview with the author, June 1969).

Jean Leymarie, director of the Musée Nationale d'Art Moderne in Paris, concurs. He has been a close friend of Picasso's since 1944 and spent a great deal of time in the Picasso household while his young daughter was living with the Picassos. Those to whom Picasso speaks most profoundly could never take notes, or even reconstruct the conversation later, he insists. "Once when I was there he spoke for five hours about odors—of women he had known, of houses, towns, studios, et cetera. How is it possible to record all that?" Leymarie, like Picasso's other friends, made it a point to stress that Picasso never plays the professor. "One evening we were sitting around and Picasso noticed clippings of some fragments published by Kahnweiler. Looking them over quickly, he turned to me and said, *"Tiens!* Did I say that?" (interview with the author, June 1969).

Another old friend, Roland Penrose, author of several important books and many essays on Picasso, notes that "it is always through paradoxes that he makes his most profound and astonishing remarks"

(letter to author, February 7, 1969). In his major book on Picasso, he describes the experience of a listener:

As you listen you realize that Picasso appreciates that truth is never easily accessible. Direct statements imply falsehoods too often for them to be trusted. The truth can be better understood by subtle maneuvers which catch it alive instead of trampling it to death. His short, eager interruptions are like well-aimed gunfire which not only tears breaches in conventional defences against possible disconcerting revelations, but pierces a way to a more profound understanding of life and the arts.

To record these conversations would be difficult. They rely on glances, expressions, gestures, a quick laugh which introduces a relative absurdity, and above all on the reactions of his listeners to ambiguities and paradoxes which can become the threshold of new ideas. The pleasure Picasso takes in presenting the reverse side of a problem can reduce the over-serious questioner to despair. "You mustn't always believe what I say," he once told me. "Questions tempt you to tell lies, particularly when there is no answer." (Roland Penrose, 1958 [1962, page 366])

Still more testimony to Picasso's elliptical conversational style can be found in Dor de la Souchère's book describing how Picasso went about creating his own museum in Antibes. During that time the author kept daily notes on Picasso's conversation, which he characterizes as follows: "He proceeds by means of flashes of verbal lightning, or fulgurations, but not without first taking precautions. 'If you take my sayings and explode them in the air, they remain only sayings. But if you fit them together in their correct places, you will have the whole story' " (Dor de la Souchère, 1960, page 13).

In general Picasso tries to elude his eager Boswells and has a distinct aversion to being quoted. "Picasso almost has a nervous breakdown in front of a tape recorder," writes Georges Boudaille, "and his intimate friends know that he doesn't want them to reproduce his words. For instance, in the Clouzot film, *Le Mystère Picasso*, he only says three words: 'That's going badly!' " (letter to the author, April 25, 1969). The proof of Boudaille's remarks lies in the fact that among those who have had the longest association with Picasso there

appears to be an unwritten rule never to quote Picasso directly. Pierre Daix, another author of a book-length study, says that Picasso hates to be recorded, and that he once told Picasso that he was like a primitive that didn't want to be photographed, to which Picasso replied instantly: "Exactly!" (conversation with the author, May 1969).

In most of the extended essays on Picasso there are remarkably few direct quotations. The whole of the vast Picasso literature contains only three documents that have been verified by Picasso himself: the 1923 statement given to Marius de Zayas, an American art critic; the 1935 statement taken by Christian Zervos and checked over by Picasso; and Jerome Seckler's postwar interview. These three documents are published in full in this book. In addition, there are statements in the various writings of Jaime Sabartés, the friend of Picasso's boyhood who was his confidant and secretary for long periods of time, which are considered indisputable. Madame Parmelin, wife of the painter Pignon, with whom Picasso often speaks about painting, is considered extremely accurate. Zervos, whose association with Picasso covered more than fifty years, considered that Madame Parmelin's ear for Picasso's intonation and manner of speaking was nearly perfect. After Sabartés, he recommended her books as the best source for direct quotations.

The consequences of taking Picasso's paradoxes out of their contexts and away from what Leiris called their "occasion" emerge in reading the texts, which frequently seem to contradict one another. If, as Picasso suggested, you could only fit them together, they might give the whole story. In the flow of his life's thought, many of these statements would not appear as contraries. For example, in 1923 he told De Zayas that intentions don't count, but years later he told Madame Parmelin that what really mattered to the cubists were the intentions, not the work. In context, it emerges that he was in fact speaking on two different subjects. In the first statement he was impatient with the rhetoric that had attached to his cubist period, and wished to stress that only in the work itself could the aesthetic be divined. In the second statement, he was reminiscing about the camaraderie that existed for a time during those early years. To take another example, he derides the idea that painting is a form of research in 1923 but tells Alexander Liberman in 1956 that his painting is nothing but research and experiment. In their contexts, these seem-

ingly contrary statements deal with very different themes and, above all, respond to very different questions. Picasso often says a picture cannot be plotted beforehand, and he often says that nothing is an accident. Are these contraries? Or he makes fun of art for art's sake one day, and another day he asks, why not? It all depends on who is asking, why he asks, and what the specific circumstances are. If the questioner is obtuse and irritating enough, Picasso is capable of masterly deceptions. He does not want to supply the columns of the popular press with small talk. This attitude goes back a long way, as André Salmon, a friend in the first decade of the century, confirms. Salmon is describing a manifesto that Apollinaire wished him to sign, which he refused to do. "On this level I always found myself less close to Guillaume Apollinaire than to Picasso, who refused to exploit cubism—his own cubism—and responded to an irresponsible journalist, 'Negro art? Never heard of it' " (André Salmon, *Deuxième Epoque* [*1908–1920*], page 232).

The format of this book limited the text to direct quotations attributed to Picasso, but in many ways I think that a thorough study of Picasso's views on art would have to include a close reading of the major poets with whom Picasso has been associated. He has said that he values his friendship with the poets partly because they were respectful and attentive viewers who did not attempt to impose their ideas on painters. He has also readily admitted that certain poets were influential in his own development. Salmon recalls his very first meeting with Picasso and the poet Max Jacob: "It was with this day, according to Picasso, who for once consented to overwhelm an interviewer with something other than foolery, that 'that epoch where painters and poets influenced each other reciprocally' opened" (André Salmon, *Première Epoque* [*1903–1908*], page 166). Picasso's affection for poets, evident in the long list of their books he has illustrated, has a history as long as his own history as a painter. Maurice Raynal describes his first visit to Picasso's studio, before 1905, where he saw volumes of Rimbaud, Mallarmé, and Baudelaire. Years later the art dealer Pierre Loeb mentions long conversations with Picasso about the Spanish poet Gongora (*Voyages à travers la peinture*, Bordas, 1945).

Those with whom he was most intimate—among them Jacques Prévert, Aragon, Paul Eluard, Pierre Reverdy, Michel Leiris, and

Francis Ponge—have written with assurance and insight. They were exceptionally close listeners and, in some cases, one can hear Picasso in their words better than one can hear Picasso in his own words—or at least in the words that are attributed to him on paper. In my opinion, the writings by Paul Eluard, who spent many hours in Picasso's studio, are superb reflectors. Eluard listened with great attention. He looked with great attention. Picasso's views shine through his essays and poems as Delacroix's views shine through Baudelaire's essays and poems. (Baudelaire was an expert studio listener and made many of the ideas he gleaned from his favorite artists into his own. He is a prime example of that "reciprocal" influence to which Picasso referred.) Eluard's exposition of Picasso's vision illuminates not only Picasso's aesthetic position, but also his own. He speaks for them both. Many of his own thoughts, familiar to readers of his early poetry and essays, find their perfect form when they gravitate to Picasso. Similarly, many of Picasso's reported thoughts find their completion in the beautiful prose, and still more beautiful poems, offered by Eluard to his old friend.

For instance, Eluard's attitude toward concrete objects, the senses, and the mind is identical with Picasso's as suggested in De Zayas and later Zervos:

In general, the mind first attempts to distinguish things and their relationships: things furnish concrete ideas, and their relationships, abstract ideas, and because of that, you have to go from subject to object. Now, to follow this path from subject to object, you must have a certain amount of sympathy or antipathy—in other words, notions of value. . . . (Eluard, 1944, page 31)

Picasso's consistent view that the painter is an interpreter and not an imitator of the world of objects and emotions is echoed in the following passage:

Painters have been victims of their means. Most of them are woefully limited to reproducing the world. When they made their portraits, it was by looking at themselves in the mirror, without reflecting that they themselves were a mirror. . . . Picasso, by passing all sentiments of sympathy and antipathy, which are scarcely differentiated, which are only vehicles of movement, of progress, systematically tried—and

he succeeded—to unravel the thousands of complicated relationships between man and nature. He attacked that reality called intangible when it is only arbitrary . . . that reality partook of him as he partook of it: a communal, indissoluble presence. (Eluard, 1944, page 32)

Eluard and Picasso also share their vision of truth:

Picasso wants truth. Not that fictive truth which always leaves Galatea inert and lifeless, but a total truth which unites nature and imagination, which considers everything real, and which, always proceeding from the particular to the universal and from the universal to the particular, accommodates itself to all the varieties of existence, of change, provided they are new and fertile. (Eluard, 1944, page 35)

Finally, I call attention to Eluard's well-known view of universality, and his lifelong study of seeing and discerning (not the "perception" of which psychologists and scientists speak, but the *discerning* without which no poet can move us to see the world anew):

For the artist as for the least cultivated man, there are neither concrete nor abstract forms. There is only communication between what sees and what is seen. . . . To see is to understand, to judge, to transform, to imagine, to forget or forget oneself, to be, or to disappear. (Eluard, 1944, page 36)

More than once in the following texts Picasso indicates that for him, "there is only communication between what sees and what is seen."

The nature of his relationships to the poets emerges in his work, where, when he undertakes to illustrate their poems, he clearly indicates how well he understands and cherishes them. But it also emerges in the works of the poets. On numerous occasions the poets refer to Picasso, either in conversation or in terms of his meaning in the contexts of their lives. How closely Picasso related to the essential lives of his poetic friends is very well indicated in a text by Michel Leiris. After establishing himself very young as a surrealist poet in good standing, Leiris undertook his second career as an ethnologist. In this role he participated in numerous important field studies all over the world, and eventually became a curator in the Musée de

l'Homme, where he still works. In his collection of prose poems, in which dream and reality are faithfully fused, Leiris enters his fantasies from 1923 to 1960. Some of these "dreams" are labeled "lived," as though to differentiate them from the others, but they are equally exalted and laced with the peculiar fantasy that has marked his work from the beginning. The entry dated 4–5 March 1947 is a particularly good example of Leiris's style, and suggests why Picasso would have found Leiris such a stimulating friend (especially in view of Picasso's own poetic style):

Place du Trocadéro, in front of the entrance to the Musée de l'Homme, I am fighting a winged bull. As I am about to drive my sword through his heart, I realize he has no more substance than a tinsel animal. This episode leaves me, on awakening, with the optimistic impression that there are many things which were really nothing at the very moment one was creating a world with them.

In another dream nearly fourteen years earlier, and itself a version of a still older dream, I had to participate in a boxing match for the benefit of the Museum. This didn't please me at all, and I took off my robe at the very last minute, declaring shamelessly that I didn't look forward to being knocked out.

The idea of combat associated with my profession as ethnographer was undoubtedly inspired by the fact that in 1931 the world's champion bantamweight (Al Brown, a Panamanian black so elegant in the ring that the public nicknamed him the *danseuse*) put on a fight at the Cirque d'Hiver for the benefit of the Dakar-Djibouti Mission. I also recall the admission a professional boxer once made to Picasso and which Picasso reported to me as an indication of what unimaginable things a man inside the ropes must endure: "It is as if you were going down to the bottom of the sea." (Leiris, 1961, page 169)

Boxers, ethnographers, bullfighters, workers, printers—they have attracted Picasso's interest. Nearly all the artisans with whom Picasso has ever worked cannot praise him highly enough. He may be suspicious of intellectuals and art critics, but before those with concrete skills he is always respectful. When *Les Lettres Françaises* prepared a special issue for Picasso's eightieth birthday (No. 898, October 26–November 1, 1961) there was ample testimony to his genuine friendship for the artisans who helped him to print his etchings and lithographs. The intaglio master printer Roger Lacourière wrote of how

animated his atelier became from the moment in 1933 when Picasso first started frequenting it. "That was for us an extraordinary period because his presence brought us an ambiance of enthusiasm, of constant experiment, and discoveries in the technique never known before. . . ." And the lithographer Fernand Mourlot records his pride in the relationship, recounting how Picasso—he who always rose at eleven-thirty a.m.!—would appear every morning at the atelier at nine and would often stay long into the night. "During this time, Pablo was happy—he had become a true lithographic craftsman, faithful, exact."

Picasso also maintained excellent relationships with editors and makers of books, one of whom exclaimed, "To make a book with Picasso is always an enchantment!" (Pierre Benoit, a poet in an obscure southern French town, Alès, where he publishes limited editions of his own and other poets' works, very often with frontispieces by Picasso). Another tribute appears in the eightieth-anniversary issue of *Les Lettres* from Charles Feld, an editor of art books for Le Cercle d'Art. "He has the secret gift of putting you at your ease," Feld reported, "and he never interferes in the domain that he considers yours." Whatever the problem—whether one of reproduction, layout, or text—Picasso would invariably respond: It's your *métier!* "With him relations remain simple, as between workers engaged in the same task. . . . I've had relationships with many artists, but never has the human contact been so direct, so intense as that felt with Picasso."

The Barcelona publisher Don Gustavo Gili was so moved by Picasso's extraordinary warmth during the long history of the publishing of the *Tauromachia of Pepe Illo* that he published a little book on the subject. The idea of the *Tauromachia* had first been broached to Picasso in 1927 by Don Gustavo's father, who had been a boyhood friend of Picasso's. By the time it was published, in 1959, Picasso had become the close friend of his friend's son and had demonstrated his friendship in numerous ways which Don Gustavo recounts in his little *Notebook of the Tauromachia of Pepe Illo.* Again and again the publisher marvels at Picasso's patience, his perfectionism, and, above all, his easy working relationship with his collaborators.

Affectionate descriptions of Picasso's character naturally enough occur in the works of his closest friends. When hostility appears, it is usually in the writings of strangers, such as occasional journalists and

professional feature writers. Among artists who have known him, Picasso is generally highly esteemed, not only for his work, but for his generosity in their regard. When the German painter Otto Freundlich took refuge in Paris, he found Picasso consistently warm and generous ("Memoirs," *Prisme des Arts* No. 8, January 1957). Numerous young Spanish artists have spoken of his kindness, and Madame Parmelin recounts frequent incidents establishing Picasso's genuine respect for all other artists. Zervos has always been emphatic on the point: Picasso never belittled or attacked another painter seriously, not even his greatest rivals.

One afternoon we were at the Coupole with a number of people, among them Matisse and Picasso. Matisse left for a minute. When someone asked what had become of him, Picasso answered that he was assuredly sitting on his crown of laurels. Most of those present, thinking they might please Picasso, began attacking Matisse. Then Picasso became furious and cried out: "I refuse to let you say anything against Matisse, he is our greatest painter." (Letter to the author, July 27, 1966)

Zervos comments that "everything is like that for Picasso. His sallies are witty but never malicious."

Kahnweiler also speaks of Picasso's respectful attitude toward his *confrères*, saying that although Picasso was against abstract painting, he was never against abstract painters. Both Kahnweiler and Parmelin, who tend to be cool toward abstract painting, seem to have encouraged Picasso often to speak on the subject, and their records of his remarks reflect, undoubtedly, their own particular interests. Zervos, who had maintained cordial relations with many abstract artists over the years, was not likely to lead his conversations with Picasso in a similar direction. "He never said a word against abstract art," Zervos maintained. "He always said, 'I am not a critic' " (conversation with the author, June 1965).

Among the less affectionate, lengthy accounts of Picasso's character is the extensively read and quoted book by his former companion Françoise Gilot and the professional writer Carleton Lake, *My Life with Picasso*. The book drew Picasso's wrath. When it appeared in Paris, he instituted a libel suit, which he lost. But in support of his

contentions some forty-four distinguished artists and writers published a public protest. They repudiated the book largely on the basis of its invasion of his personal privacy and suggested that it was not reliable factually.

While I was considering the inclusions in this anthology, I studied the book closely. Later I visited several of the signers of the protest. Those whose integrity is above suspicion, and who have known Picasso longest, did not hesitate to document small incidents of Gilot's distortions regarding his personal life, and most of them felt that her renditions of Picasso's views on art were no less distorted. They all said the tone was never right and reminded me that Picasso was not given to lectures and disquisitions. The lengthy passages within quotation marks were uncharacteristic. "All those philosophic theories she threw in!" Kahnweiler exclaimed. "Picasso never, never spoke of Kant or Plato."

Nevertheless, they did notice that a few phrases rang true. In studying the texts again, I think I have discovered why that is so: the authors seem to have had recourse to such established statements as those reported by De Zayas and Zervos and have simply expanded them. The mixture of possible authentic statement and artful paraphrase seems to me to be of dubious value. Since the book is also in paperback and readily available, I don't think my editorial exclusion is unwarranted. I have also excluded numerous journalists' accounts and interviews made by professionals ranging from an astrologer to a gossip columnist, when I felt I had established to my own satisfaction that there was very little of Picasso left in their clumsy renditions.

DORE ASHTON

Following each selection is a citation in parentheses that refers to the list of sources in Bernard Karpel's bibliography, which begins on page 175. When the source is a book, the author's name, the date of original publication, and the page numbers are given; when another edition has been used, its date of publication and page numbers appear in brackets. When the source is a magazine, only the author's name and the date of the magazine's publication are given.

Where credit for translation into English is not given in the bibliography, the translations are my own.

DORE ASHTON

Picasso on Art

Two Statements
by Picasso

1923

The following statement was made in Spanish to Marius de Zayas. Picasso approved De Zayas' manuscript before it was translated into English and published in The Arts, *New York, May 1923, under the title "Picasso Speaks." It was reprinted in Alfred H. Barr, Jr., 1946.*

I can hardly understand the importance given to the word *research* in connection with modern painting. In my opinion. to search means nothing in painting. To find, is the thing. Nobody is interested in following a man who, with his eyes fixed on the ground, spends his life looking for the pocketbook that fortune should put in his path. The one who finds something no matter what it might be, even if his intention were not to search for it, at least arouses our curiosity, if not our admiration.

Among the several sins that I have been accused of committing, none is more false than the one that I have, as the principal objective in my work, the spirit of research. When I paint my object is to show what I have found and not what I am looking for. In art intentions are not sufficient and, as we say in Spanish: love must be proved by facts and not by reasons. What one does is what counts and not what one had the intention of doing.

We all know that Art is not truth. Art is a lie that makes us realize truth, at least the truth that is given us to understand. The artist must know the manner whereby to convince others of the truthfulness of his lies. If he only shows in his work that he has searched, and re-searched, for the way to put over lies, he would never accomplish anything.

The idea of research has often made painting go astray, and made

the artist lose himself in mental lucubrations. Perhaps this has been the principal fault of modern art. The spirit of research has poisoned those who have not fully understood all the positive and conclusive elements in modern art and has made them attempt to paint the invisible and, therefore, the unpaintable.

They speak of naturalism in opposition to modern painting. I would like to know if anyone has ever seen a natural work of art. Nature and art, being two different things, cannot be the same thing. Through art we express our conception of what nature is not.

Velázquez left us his idea of the people of his epoch. Undoubtedly they were different from what he painted them, but we cannot conceive a Philip IV in any other way than the one Velázquez painted. Rubens also made a portrait of the same king and in Rubens' portrait he seems to be quite another person. We believe in the one painted by Velázquez, for he convinces us by his right of might.

From the painters of the origins, the primitives, whose work is obviously different from nature, down to those artists who, like David, Ingres and even Bouguereau, believed in painting nature as it is, art has always been art and not nature. And from the point of view of art there are no concrete or abstract forms, but only forms which are more or less convincing lies. That those lies are necessary to our mental selves is beyond any doubt, as it is through them that we form our aesthetic point of view of life.

Cubism is no different from any other school of painting. The same principles and the same elements are common to all. The fact that for a long time cubism has not been understood and that even today there are people who cannot see anything in it, means nothing. I do not read English, an English book is a blank book to me. This does not mean that the English language does not exist, and why should I blame anybody else but myself if I cannot understand what I know nothing about?

I also often hear the word evolution. Repeatedly I am asked to explain how my painting evolved. To me there is no past or future in art. If a work of art cannot live always in the present it must not be considered at all. The art of the Greeks, of the Egyptians, of the great painters who lived in other times, is not an art of the past; perhaps it is more alive today than it ever was. Art does not evolve by itself, the ideas of people change and with them their mode of expression. When

I hear people speak of the evolution of an artist, it seems to me that they are considering him standing between two mirrors that face each other and reproduce his image an infinite number of times, and that they contemplate the successive images of one mirror as his past, and the images of the other mirror as his future, while his real image is taken as his present. They do not consider that they all are the same images in different planes.

Variation does not mean evolution. If an artist varies his mode of expression this only means that he has changed his manner of thinking, and in changing, it might be for the better or it might be for the worse.

The several manners I have used in my art must not be considered as an evolution, or as steps toward an unknown ideal of painting. All I have ever made was made for the present and with the hope that it will always remain in the present. I have never taken into consideration the spirit of research. When I have found something to express, I have done it without thinking of the past or of the future. I do not believe I have used radically different elements in the different manners I have used in painting. If the subjects I have wanted to express have suggested different ways of expression I have never hesitated to adopt them. I have never made trials nor experiments. Whenever I had something to say, I have said it in the manner in which I have felt it ought to be said. Different motives inevitably require different methods of expression. This does not imply either evolution or progress, but an adaptation of the idea one wants to express and the means to express that idea.

Arts of transition do not exist. In the chronological history of art there are periods which are more positive, more complete than others. This means that there are periods in which there are better artists than in others. If the history of art could be graphically represented, as in a chart used by a nurse to mark the changes of temperature of her patient, the same silhouettes of mountains would be shown, proving that in art there is no ascendant progress, but that it follows certain ups and downs that might occur at any time. The same occurs with the work of an individual artist.

Many think that cubism is an art of transition, an experiment which is to bring ulterior results. Those who think that way have not understood it. Cubism is not either a seed or a foetus, but an art

dealing primarily with forms, and when a form is realized it is there to live its own life. A mineral substance, having geometric formation, is not made so for transitory purposes, it is to remain what it is and will always have its own form. But if we are to apply the law of evolution and transformation to art, then we have to admit that all art is transitory. On the contrary, art does not enter into these philosophic absolutisms. If cubism is an art of transition I am sure that the only thing that will come out of it is another form of cubism.

Mathematics, trigonometry, chemistry, psychoanalysis, music and whatnot have been related to cubism to give it an easier interpretation. All this has been pure literature, not to say nonsense, which brought bad results, blinding people with theories.

Cubism has kept itself within the limits and limitations of painting, never pretending to go beyond it. Drawing, design and color are understood and practiced in cubism in the spirit and manner that they are understood and practiced in all other schools. Our subjects might be different, as we have introduced into painting objects and forms that were formerly ignored. We have kept our eyes open to our surroundings, and also our brains.

We give to form and color all their individual significance, as far as we can see it; in our subjects, we keep the joy of discovery, the pleasure of the unexpected; our subject itself must be a source of interest. But of what use is it to say what we do when everybody can see it if he wants to?

1935

Christian Zervos put down these remarks of Picasso immediately after a conversation with him at Boigeloup, his country place, in 1935. When Zervos wanted to show Picasso his notes Picasso replied: "You don't need to show them to me. The essential thing in our period of weak morale is to create enthusiasm. How many people have actually read Homer? All the same the whole world talks of him. In this way the Homeric legend is created. A legend in this sense provokes a valuable stimulus. Enthusiasm is what we need most, we and the younger generation."

Zervos reports, however, that Picasso did actually go over the notes and approved them informally. They were published under the title "Conversation avec Picasso" in Cahiers d'Art *in 1935. The following translation is based on one by Myfanwy Evans and first appeared in Alfred H. Barr, Jr., 1946, from which the comments above have been borrowed.*

We might adopt for the artist the joke about there being nothing more dangerous than implements of war in the hands of generals. In the same way, there is nothing more dangerous than justice in the hands of judges, and a paintbrush in the hands of a painter. Just think of the danger to society! But today we haven't the heart to expel the painters and poets from society because we refuse to admit to ourselves that there is any danger in keeping them in our midst.

It is my misfortune—and probably my delight—to use things as my passions tell me. What a miserable fate for a painter who adores blondes to have to stop himself putting them into a picture because they don't go with the basket of fruit! How awful for a painter who loathes apples to have to use them all the time because they go so well with the cloth. I put all the things I like into my pictures. The things—so much the worse for them; they just have to put up with it.

In the old days pictures went forward toward completion by stages. Every day brought something new. A picture used to be a sum of additions. In my case a picture is a sum of destructions. I do a picture—then I destroy it. In the end, though, nothing is lost: the red I took away from one place turns up somewhere else.

It would be very interesting to preserve photographically, not the stages, but the metamorphoses of a picture. Possibly one might then discover the path followed by the brain in materializing a dream. But there is one very odd thing—to notice that basically a picture doesn't change, that the first "vision" remains almost intact, in spite of appearances. I often ponder on a light and a dark when I have put them into a picture; I try hard to break them up by interpolating a color that will create a different effect. When the work is photographed, I note that what I put in to correct my first vision has disappeared, and that, after all, the photographic image corresponds with my first vision before the transformation I insisted on.

A picture is not thought out and settled beforehand. While it is being done it changes as one's thoughts change. And when it is finished, it still goes on changing, according to the state of mind of whoever is looking at it. A picture lives a life like a living creature, undergoing the changes imposed on us by our life from day to day. This is natural enough, as the picture lives only through the man who is looking at it.

At the actual time that I am painting a picture I may think of white and put down white. But I can't go on working all the time thinking of white and painting it. Colors, like features, follow the changes of the emotions. You've seen the sketch I did for a picture with all the colors indicated on it. What is left of them? Certainly the white I thought of and the green I thought of are there in the picture, but not in the places I intended, nor in the same quantities. Of course, you can paint pictures by matching up different parts of them so that they go quite nicely together, but they'll lack any kind of drama.

I want to get to the stage where nobody can tell how a picture of mine is done. What's the point of that? Simply that I want nothing but emotion to be given off by it.

Work is a necessity for man.

A horse does not go between the shafts of its own accord.

Man invented the alarm clock.

When I begin a picture, there is somebody who works with me. Toward the end, I get the impression that I have been working alone —without a collaborator.

When you begin a picture, you often make some pretty discoveries. You must be on guard against these. Destroy the thing, do it over several times. In each destroying of a beautiful discovery, the artist does not really suppress it, but rather transforms it, condenses it, makes it more substantial. What comes out in the end is the result of discarded finds. Otherwise, you become your own connoisseur. I sell myself nothing.

Actually, you work with few colors. But they seem like a lot more when each one is in the right place.

Abstract art is only painting. What about drama?

There is no abstract art. You must always start with something. Afterward you can remove all traces of reality. There's no danger then, anyway, because the idea of the object will have left an indelible mark. It is what started the artist off, excited his ideas, and stirred up his emotions. Ideas and emotions will in the end be prisoners in his work. Whatever they do, they can't escape from the picture. They form an integral part of it, even when their presence is no longer discernible. Whether he likes it or not, man is the instrument of nature. It forces on him its character and appearance. In my Dinard pictures and in my Pourville pictures I expressed very much the same vision. However, you yourself have noticed how different the atmosphere of those painted in Brittany is from those painted in Normandy, because you recognized the light of the Dieppe cliffs. I didn't copy this light nor did I pay it any special attention. I was simply soaked in it. My eyes saw it and my subconscious registered what they saw. my hand fixed the impression. One cannot go against nature. It is stronger than the strongest man. It is pretty much to our interest to be on good terms with it! We may allow ourselves certain liberties, but only in details.

Nor is there any "figurative" and "non-figurative" art. Everything appears to us in the guise of a "figure." Even in metaphysics ideas are expressed by means of symbolic "figures." See how ridiculous it is then to think of painting without "figuration." A person, an object, a circle are all "figures"; they react on us more or less intensely. Some are nearer our sensations and produce emotions that touch our affec-

tive faculties; others appeal more directly to the intellect. They all should be allowed a place because I find my spirit has quite as much need of emotion as my senses. Do you think it concerns me that a particular picture of mine represents two people? Though these two people once existed for me, they exist no longer. The "vision" of them gave me a preliminary emotion; then little by little their actual presences became blurred; they developed into a fiction and then disappeared altogether, or rather they were transformed into all kinds of problems. They are no longer two people, you see, but forms and colors: forms and colors that have taken on, meanwhile, the *idea* of two people and preserve the vibration of their life.

I deal with painting as I deal with things, I paint a window just as I look out of a window. If an open window looks wrong in a picture, I draw the curtain and shut it, just as I would in my own room. In painting, as in life, you must act directly. Certainly, painting has its conventions, and it is essential to reckon with them. Indeed, you can't do anything else. And so you always ought to keep an eye on real life.

The artist is a receptacle for emotions that come from all over the place: from the sky, from the earth, from a scrap of paper, from a passing shape, from a spider's web. That is why we must not discriminate between things. Where things are concerned there are no class distinctions. We must pick out what is good for us where we can find it—except from our own works. I have a horror of copying myself. But when I am shown a portfolio of old drawings, for instance, I have no qualms about taking anything I want from them.

When we invented cubism we had no intention whatever of inventing cubism. We wanted simply to express what was in us. Not one of us drew up a plan of campaign, and our friends, the poets, followed our efforts attentively, but they never dictated to us. Young painters today often draw up a program to follow, and apply themselves like diligent students to performing their tasks.

The painter goes through states of fullness and evaluation. That is the whole secret of art, I go for a walk in the forest of Fontainebleau. I get "green" indigestion. I must get rid of this sensation into a picture. Green rules it. A painter paints to unload himself of feelings and visions. People seize on painting to cover up their nakedness. They get what they can wherever they can. In the end I don't believe

they get anything at all. They've simply cut a coat to the measure of their own ignorance. They make everything, from God to a picture, in their own image. That is why the picture-hook is the ruination of a painting—a painting which has always a certain significance, at least as much as the man who did it. As soon as it is bought and hung on a wall, it takes on quite a different kind of significance, and the painting is done for.

Academic training in beauty is a sham. We have been deceived, but so well deceived that we can scarcely get back even a shadow of the truth. The beauties of the Parthenon, Venuses, nymphs, Narcissuses, are so many lies. Art is not the application of a canon of beauty but what the instinct and the brain can conceive beyond any canon. When we love a woman we don't start measuring her limbs. We love with our desires—although everything has been done to try and apply a canon even to love. The Parthenon is really only a farmyard over which someone put a roof; colonnades and sculptures were added because there were people in Athens who happened to be working, and wanted to express themselves. It's not what the artist *does* that counts, but what he *is*. Cézanne would never have interested me a bit if he had lived and thought like Jacques Émile Blanche, even if the apple he painted had been ten times as beautiful. What forces our interest is Cézanne's anxiety—that's Cézanne's lesson; the torments of Van Gogh—that is the actual drama of the man. The rest is a sham.

Everyone wants to understand art. Why not try to understand the songs of a bird? Why does one love the night, flowers, everything around one, without trying to understand them? But in the case of a painting people have to *understand*. If only they would realize above all that an artist works of necessity, that he himself is only a trifling bit of the world, and that no more importance should be attached to him than to plenty of other things which please us in the world, though we can't explain them. People who try to explain pictures are usually barking up the wrong tree. Gertrude Stein joyfully announced to me the other day that she had at last understood what my picture of the three musicians was meant to be. It was a still life!

How can you expect an onlooker to live a picture of mine as I lived it? A picture comes to me from miles away: who is to say from how far away I sensed it, saw it, painted it; and yet the next day I can't see

what I've done myself. How can anyone enter into my dreams, my instincts, my desires, my thoughts, which have taken a long time to mature and to come out into the daylight, and above all grasp from them what I have been about—perhaps against my own will?

With the exception of a few painters who are opening new horizons to painting, young painters today don't know which way to go. Instead of taking up our researches in order to react clearly against us, they are absorbed with bringing the past back to life—when truly the whole world is open before us, everything waiting to be done, not just redone. Why cling desperately to everything that has already fulfilled its promise? There are miles of painting "in the manner of"; but it is rare to find a young man working in his own way.

Does he wish to believe that man can't repeat himself? To repeat is to run counter to spiritual laws; essentially escapism.

I'm no pessimist, I don't loathe art, because I couldn't live without devoting all my time to it. I love it as the only end of my life. Everything I do connected with it gives me intense pleasure. But still, I don't see why the whole world should be taken up with art, demand its credentials, and on that subject give free rein to its own stupidity. Museums are just a lot of lies, and the people who make art their business are mostly impostors. I can't understand why revolutionary

countries should have more prejudices about art than out-of-date countries! We have infected the pictures in museums with all our stupidities, all our mistakes, all our poverty of spirit. We have turned them into petty and ridiculous things. We have been tied up to a fiction, instead of trying to sense what inner life there was in the men who painted them. There ought to be an absolute dictatorship . . . a dictatorship of painters . . . a dictatorship of one painter . . . to suppress all those who have betrayed us, to suppress the cheaters, to suppress the tricks, to suppress the mannerisms, to suppress charms, to suppress history, to suppress a heap of other things. But common sense always gets away with it. Above all, let's have a revolution against that! The true dictator will always be conquered by the dictatorship of common sense . . . and maybe not!

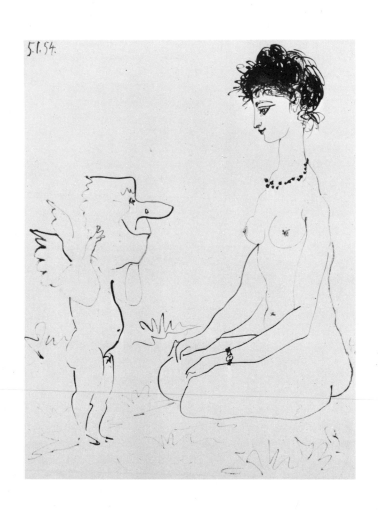

Art and Eroticism

"Art is never chaste," Picasso told me one day. "We forbid it to the ignorant innocents, never allow a contact with it to those not sufficiently prepared. Yes, art is dangerous. And, if it's chaste it isn't art." (Vallentin, 1957, page 268)

And when, one day, someone said apropos of nothing in particular that there can be no sense of shame in art, he answered that painting could paint anything, provided that it was really painting.
"Only when painting isn't really painting can there be an affront to modesty," said he. (Parmelin, 1965, page 160)

"Art is never chaste," he told me one day as he was showing me some erotic woodcuts of Utamaro. . . . (Brassaï, 1966, page 164)

Art and Intellect

"Some are nearer our sensations and produce emotions that touch our affective faculties; others appeal more directly to the intellect. They all should be allowed a place because I find my spirit has quite as much need of emotion as my senses." (Zervos, 1935)

=========

"An idea," he said, letting himself be carried away by his own, "is a point of departure and no more. If you contemplate it, it becomes something else. What I ponder a great deal, I achieve mentally. How can you then expect me to continue being interested in it? If I persist, it turns out differently, because a different matter intervenes. As far as I am concerned, at any rate, my original idea has no further interest, because in realizing it I am thinking about something else." (Sabartés, 1946, page 146)

"Painting is a thing of intelligence. One sees it in Manet. One can see the intelligence in each of Manet's brushstrokes, and the action of intelligence is made visible in the film on Matisse when one watches Matisse draw, hesitate, then begin to express his thought with a sure stroke." (Liberman, 1956)

I show him these strange faces, created from two or three hollows in the wall, but so evocative, so expressive. In several of his sculptures Picasso seems to have been inspired by them, or rather to have had a meeting with them.

PICASSO: "Look at these eyes. They are deep holes cut into the wall. But some of them seem to be protuberant, as if they were done in

relief. What causes that? It's not an optical effect. We can see very clearly that they are holes. Our knowledge influences our vision." (Brassaï, 1966, page 202)

Notre Dame de Vie
February 2, 1964

PICASSO: One simply paints—one doesn't paste one's ideas on a painting.

I: Certainly, the painter paints things and not ideas.

PICASSO: Certainly, if the painter has ideas, they come out of how he paints things. (Guttuso, 1964)

Art and Nature

"They speak of naturalism in opposition to modern painting. I would like to know if anyone has ever seen a natural work of art. Nature and art, being two different things, cannot be the same thing. Through art we express our conception of what nature is not." (De Zayas, 1923)

═══════

"It's not after nature I'm painting, but before nature, with it." (Tériade, 1932)

"Whether he likes it or not, man is the instrument of nature. It forces on him its character and appearance." (Zervos, 1935)

"I have been shown an issue of *Arts*," he tells us, "in which Raymond Cogniat writes that my art is 'monstrous,' 'inhuman.' This surprised me because on the contrary, I always try to observe nature. As you can see, I've put in this still-life a box of leeks, all right, I wanted my canvas to smell of leeks. I insist on likeness, a more profound likeness, more real than the real, achieving the surreal. This is the way I understood (conceived) surrealism but the word had been used quite differently."

"But nature . . ."

"Nature is one thing and painting is quite another. Painting is the equivalent of nature. We must thank the painters for the image we have of nature. We perceive it through their eyes. Generally speaking, we stick to the reproductions which the classical painters gave us, like the painters of the seventeenth century, Poussin. The image they give is accepted as the true nature, because their syntax is well established.

But we have no assurance that this image is truer than other images created in other epochs. Actually it isn't anything more than a question of signs. It has been agreed upon that a specific sign represents a tree, another a house, a man, a woman; exactly as in a language the word 'man' evokes the image of a man, the word 'house' a house and this in all languages although in every language the word varies. It's an established convention, we communicate by the use of these signs." (Warnod, 1945)

"No doubt, it is useful for an artist to know all the forms of art which have preceded or which accompany his. That is a sign of strength if it is a question of looking for a stimulus or recognizing mistakes he must avoid. But he must be very careful not to look for models. As soon as one artist takes another as model, he is lost. There is no other point of departure than reality. Why should I copy this owl, this sea-urchin? Why should I try to imitate nature? I might just as well try to trace a perfect circle. What I have to do is to utilize as best I can the ideas which objects suggest to me, connect, fuse and color in my way the shadows they cast within me, illumine them from the inside. And since of necessity my vision is quite different from that of the next man, my painting will interpret things in an entirely different manner even though it makes use of the same elements." (Parrot, 1948)

Speaking of his ceramic pots: "I work like the Chinese, the Mexicans, not after nature, but *like* nature." (Roy, 1956, page 85)

Recently at Cannes, after finishing a bold and evocative drawing of a bearded head wearing horns like some ancient shepherd king, beside whom was seated a faunlike creature piping to the stars, Picasso said, "It is strange, in Paris I never draw fauns, centaurs or mythical heroes like these, they always seem to live in these parts." (Penrose, 1958, page 144)

At the chapter on "Primitive Images," an "Aztec" head makes him pause abruptly, and then he cries: "That is as rich as the façade of a cathedral! . . . Your book links art with the primitive arts. . . . And it also shows—and this is important—that abstract art is not far re-

moved from the random brushstrokes or carvings in a wall. No matter
what anyone thinks or says, we always imitate something, even when
we don't know we are doing it. And when we abandon nude models
hired at so many francs an hour, we 'pose' all sorts of other things.
Don't you agree?" (Brassaï, 1966, page 242)

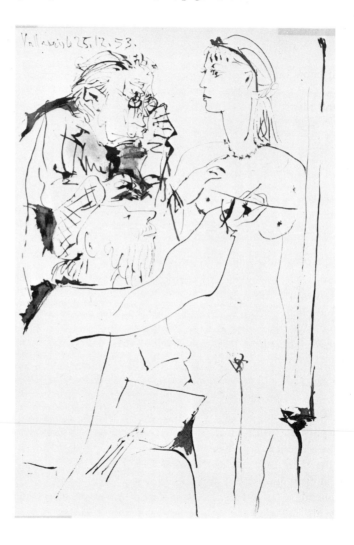

Art and Truth

"We all know that Art is not truth. Art is a lie that makes us realize truth, at least the truth that is given us to understand. The artist must know the manner whereby to convince others of the truthfulness of his lies." (De Zayas, 1923)

———

"How correct is the saying: 'If bearded, he must be Saint Anthony; otherwise, the Immaculate Conception.' That's just the way it is, and it is fine. What's the use of disguises and artificialities in a work of art? What counts is what is spontaneous, impulsive. That is the truth ful truth. What we impose upon ourselves does not emanate from ourselves." (Sabartés, 1946, page 145)

"What truth?" says Picasso. "Truth cannot exist.

"If I pursue a truth on my canvas, I can paint a hundred canvases with this same truth. Which one, then, is the truth? And what is truth—the thing that acts as my model, or what I am painting? No, it's like in everything else. Truth does not exist."

"I remember," says Paulo Picasso, "when I was very little, I heard you say all the time: 'Truth is a lie.' . . ." (Parmelin, 1965, page 110)

"If there were only one truth, you couldn't paint a hundred canvases on the same theme." (Parmelin, 1969, page 115)

Understanding Art

"Everyone wants to understand art. Why not try to understand the songs of a bird? Why does one love the night, flowers, everything around one, without trying to understand them? But in the case of a painting people have to *understand*. If only they would realize above all that an artist works of necessity, that he himself is only a trifling bit of the world, and that no more importance should be attached to him than to plenty of other things which please us in the world, though we can't explain them. People who try to explain pictures are usually barking up the wrong tree. Gertrude Stein joyfully announced to me the other day that she had at last understood what my picture of the three musicians was meant to be. It was a still life!" (Zervos, 1935)

"One more question: would you say that there is a divorce between the artist and the public?"

"Yes, at the moment at any rate. But neither the artist nor the public is to blame for that. The public still doesn't understand modern art, and that's a fact, but the reason is that nothing has been taught about painting. They have been taught to read and to write, to draw and to sing, but it has never occurred to anyone to teach people how to look at a painting. That it possibly could have poetry in color, a life of form or rhythm—in short, they are completely ignorant of the plastic values (*rimes*) we've been talking about. No more than they can appreciate a poetic image or a musical assonance. . . ." (Jakovsky, 1946, page 9)

"Those trying to explain pictures are as a rule completely mistaken." (Larrea, 1947, page 52)

"The secret of many of my deformations—which many people do not understand—is that there is an interaction, an intereffect between the lines in a painting; one line attracts the other and at the point of maximum attraction the lines curve in towards the attracting point and form is altered.

"This change through attraction, that's what the collector never sees and will never understand in a painting," he said contemptuously. "And often one does a painting really for a corner of the canvas that no one looks at."

He added: "One does a whole painting for one peach and people think just the opposite—that that particular peach is but a detail." (Liberman, 1956)

"I do not understand English," he says, "but why should I blame anybody but myself if I do not understand what I don't know?"

In this regard, Zervos mentions a significant characteristic: "One day while we were talking about the accusations often expressed to him for having suppressed the real in painting, he picked up some photographs of his works from my table, and on their margins drew the images of the objects represented, line for line. . . . All the elements of the real had been scrupulously preserved during their transposition on canvases." (Vallentin, 1957, page 184)

"One day I said to Pablo: 'Why don't you give me a few basic notions of painting so that I can orient myself a bit in that field?' But he only answered: 'The time will come when you will suddenly realize that, without any help from outside, you've learned all you need to know. Anything I might explain to you meanwhile would be of no earthly use to you.' " (Dominguin, 1961)

"Enough of Art. It's Art that kills us. People no longer want to do painting: they make Art. People want Art. And they are given it. But the less Art there is in painting the more painting there is."

And sometimes he looks at canvases and says: "There's still Art in that one. But already a certain truth all the same." (Parmelin, 1964, page 30)

"Something holy, that's it," Picasso says. "It's a word something like that we should be able to use, but people would take it in the wrong way. You ought to be able to say that a painting is as it is, with its capacity to move us, because it is as though it were touched by God. But people would think it a sham. And yet that is what's nearest to the truth."

No explanation can be given in words. Except that by some liaison between the man-creator and what is highest in the human spirit, something happens which gives this power to the painted reality.

"You can search for a thousand years," Picasso says. "And you will find nothing. Everything can be explained scientifically today. Except that. You can go to the moon or walk under the sea, or anything else you like, but painting remains painting because it eludes such investigation. It remains there like a question. And it alone gives the answer."

It has that good fortune. And that misfortune. And we too. (Parmelin, 1964, page 16)

▌▌

A Picture Not Settled Beforehand

"A picture is not thought out and settled beforehand. While it is being done it changes as one's thoughts change. And when it is finished, it still goes on changing, according to the state of mind of whoever is looking at it. A picture lives a life like a living creature, undergoing the changes imposed on us by our life from day to day. This is natural enough, as the picture lives only through the man who is looking at it." (Zervos, 1935)

"I see," he confessed to me recently, "for others, that is to say, in order to put on canvas the sudden apparitions which come to me, I don't know in advance what I am going to put on canvas any more than I decide beforehand what colors I am going to use. While I am working I am not conscious of what I am putting on the canvas. Each time I undertake to paint a picture I have a sensation of leaping into space. I never know whether I shall fall on my feet. It is only later that I begin to estimate more exactly the effect of my work." (Zervos, 1932, page xv)

"You have to have an idea of what you are going to do, but it should be a vague idea." (Kahnweiler, 1946, page 83)

How often Picasso had told me that while intending to paint a bunch of flowers, for example, he had painted a guitar or something else! . . .
"A guitar! Do you know that when I painted my first guitars I had never had one in my hands? With the first money they gave me I bought one, and after that I never painted another. People think the bullfights in my pictures were copied from life, but they are mistaken. I used to paint them before the bullfight so as to make some money to buy my ticket. Have you ever really done what you planned to do? On leaving your house do you not often change your route without thinking about it? Do you cease to be yourself on that account? And do you not get there anyhow? And even if you don't does it matter? The reason is that you didn't have to go in the first place, and you would have been wrong to force destiny." (Sabartés, 1946, pages 145–146)

PICASSO: "Actually, all my paintings were like this in the beginning, but they changed later. The luminous colors were buried under others and even the theme has often changed, a personage coming from the right to the left, or vice versa."
Some days ago, Picasso told me that he always thinks of the *Women of Algiers* the next day, wondering how they'll look, and he repeats: "You understand, it's not a question of 'time found' (*temps retrouvé*), but of 'time to discover.'" (Kahnweiler, 1955, *Aujourd'hui*)

"One never knows what one is going to do. One starts a painting and then it becomes something quite else. It is remarkable how little the 'willing'* of the artist intervenes. It's uncomfortable always to have a 'connoisseur' standing next to you telling you 'I don't like this' or 'This is not at all as it should be.' He hangs on to the brush, which becomes heavy, very heavy. Certainly he doesn't understand a thing but he is always there. The other was right when he said, *'Je est un autre.'* " (Kahnweiler, 1959)

On Picasso's improvised columns for ballet decor: "I asked if he had calculated their approach, if he had planned on them, or if he had been surprised by them. He answered that the artist is always calculating without knowing, that the Doric column came forth as a hexameter does, from an operation of the senses, and that he had perhaps just invented that column in the same way the Greeks had discovered it." (Cocteau, 1956, page 102)

"For me each painting is a study. I say to myself, I am going one day to finish it, make a finished thing out of it. But as soon as I start to finish it, it becomes another painting and I think I am going to redo it. Well, it is always something else in the end. If I retouch, I make a new painting." (Liberman, 1956)

"A painting is not thought out and fixed beforehand; while one is painting it, it follows the mobility of one's thoughts. (Vallentin, 1957, page 143)

Talking to me one day, Picasso said he was sorry that in working on these heads he once spoilt his original intention. Working at night in the studio at Boisgeloup he had first built up a very complicated construction of wire which looked quite incomprehensible except when a light projected its shadow on the wall. At that moment the shadow became a lifelike portrait of Marie-Thérèse. He was delighted

* Picasso literally said "willing" and not "will" (*le vouloir et non la volonté*).—D.H.K.

at this projection from an otherwise indecipherable mass. But he said, "I went on, added plaster and gave it its present form." The secret image was lost but a more durable and splendid version, visible to all, had been evolved. And he added: "When you work you don't know what is going to come out of it. It is not indecision, the fact is it changes while you are at work." (Penrose, 1958, page 244)

As he continued to bring out more canvases I remarked upon the variations between the representational and cubist styles. I could discover no direct sequence leading in either direction. With an enigmatic smile he told me that he himself never knew what was coming next, nor did he try to interpret what he had done. "That is for others to do if they wish," he said, and to illustrate his point he brought out a large recent aquatint: a group of several figures, some old and grotesque and others young, watching an artist at work at his easel. "*You* tell me what it means, and what that old naked man who turns his back to us is doing there. Everyone who's seen it has his story about it. I don't know what's going on, I never do. If I did I'd be finished. . . . The fact that I paint so many studies is just part of my way of working. I make a hundred studies in a few days while another painter may spend a hundred days on one picture. As I continue I shall open windows. I shall get behind the canvas and perhaps something will happen." (Penrose, 1958, page 352)

"I consider a work of art as the product of calculations," he said, "calculations that are frequently unknown to the author himself. It is exactly like the carrier-pigeon, calculating his return to the loft. The calculation that precedes intelligence. Since then we have invented the compass, and radar, which enable even fools to return to their starting-point. . . . Or else we must suppose, as Rimbaud said, that it is the other self inside us who calculates." (Souchère, 1960, page 3)

Speaking of an enormous canvas, *The Charnel House*—a sort of echo to *Guernica*—which had been sketched out in charcoal and then remained for weeks in the same state, until a day when I saw a few timid areas of color appear, Picasso told me: "I'm treading very gently. I don't want to spoil the first freshness of my work. If it were possible, I would leave it as it is, while I began over and carried it to a

more advanced state on another canvas. Then I would do the same thing with that one. There would never be a 'finished' canvas, but just the different 'states' of a single painting, which normally disappear in the course of work. To finish, to achieve—don't those words actually have a double meaning? To terminate, to execute, but also to put to death, to give the *coup de grâce*? If I paint as many canvases as I do, it is because I am searching for spontaneity, and when I have expressed a thing with a degree of happiness I no longer have the courage to add anything at all. . . ." (Brassaï, 1966, page 182)

Intentions

"In art intentions are not sufficient and, as we say in Spanish: love must be proved by facts and not by reasons. What one does is what counts and not what one had the intention of doing." (De Zayas, 1923)

"Braque always said that the only thing that counts, in painting, is the intention," Picasso says, "and it's true. What counts is what one wants to do, and not what one does. That's what's important. In cubism, in the end what was important is what one *wanted* to do, the intention one had. And *that* one cannot paint." (Parmelin, 1965, page 58)

Subjects in Painting

"We give to form and color all their individual significance, as far as we can see it; in our subjects, we keep the joy of discovery, the pleasure of the unexpected; our subject itself must be a source of interest. But of what use is it to say what we do when everybody can see it if he wants to?" (De Zayas, 1923)

———

"It is my misfortune—and probably my delight—to use things as my passions tell me. What a miserable fate for a painter who adores blondes to have to stop himself putting them into a picture because they don't go with the basket of fruit! How awful for a painter who loathes apples to have to use them all the time because they do so well with the cloth. I put all the things I like in my pictures. The things— so much the worse for them; they just have to put up with it." (Zervos, 1935)

———

"Paintings have always been made as princes made their children: with shepherdesses. One never makes a portrait of the Parthenon; one never paints a Louis XV chair. One makes paintings with a village of the *midi*, a package of tobacco, an old chair." (Tériade, 1932)

We just left Don Pablo. He was doing a large charcoal drawing of a terrifically dramatic rooster. "Roosters—" he said, "we always have roosters, but like everything else in life we must discover them. Just as Corot discovered the morning and Renoir discovered little girls. Everything must be discovered—this box—a piece of paper. You must

always leave the door open, always open—and the main thing is never to turn back once you pass through that door. Never to dismay and never to compromise. Roosters have always been seen but seldom so well as in American weather vanes." (Gonzalez, 1944)

La Californie, 1946

PICASSO: I have always wanted to paint a *crocicchio.* But basically if you put together all the portraits of your friends and your children, the *crocicchio* emerges all by itself. (Guttuso, 1964)

Paris, 1948

PICASSO: There is not a greater theme than the crucifixion exactly because it's been done for more than a thousand years millions of times. If you could paint the decapitations of Louis Capet . . .
I: But it would have to be on the side of justice. There are no paintings in which the painters are not on the side of the martyrs.
PICASSO: There aren't any—but it could be done. (Guttuso, 1964)

His *"sujets"* are his loves. He's never painted an object with which he didn't have an affectionate relationship—and certainly not only on aesthetic grounds. Didn't he tell me, many years ago, "I find it monstrous that a woman should paint a pipe because she doesn't smoke it." (Kahnweiler, 1951)

"Others have asked me why I paint pipes, guitars or packages of tobacco and why these objects keep appearing in the canvases of contemporary painters. If Chardin, for instance, painted onions and peaches, it's because he painted in the country, near his kitchen, and onions and peaches were familiar sights for him. So, what could be more familiar to a painter, or painters of Montmartre or Montparnasse, than their pipe, their tobacco, the guitar hung over the couch, or the soda bottle on the café table?" (Georges-Michel, 1954)

PICASSO: "Actually, it's through one's work that one is understood. One must work, work." Then he talks of the difficulties he has in inventing—even in inventing a new subject. "There are, basically, very few subjects. Everybody is repeating them. Venus and Love become the Virgin and Child, then—maternity, but it's always the same subject. It's magnificent to invent new subjects. Take Van Gogh: Potatoes, those shapeless things! To have painted that, or a pair of old shoes! That's really something!" (Kahnweiler, 1955, *Aujourd'hui*)

We are looking at a proof of a brush etching Picasso had made the previous day. It is a strange composition: A painter in front of his easel, painting with total absorption a naked woman. But between him and the model two figures are trying to push in: a very large woman and a little bearded man. Behind the man is a horse. I ask Picasso if the bearded man is a dwarf. Picasso: "I'd be happy if one could tell me what it is! And the other figures. . . . The painter himself sees nothing: He's only looking at his picture. There are certain painters who only can look at their pictures and see nothing else." (Kahnweiler, 1959)

One speaks of a scandalous return to subject matter. "The subject, that never scared me," says Picasso. (These words are taken from a telephone conversation with Pignon, who tells him the happenings at Paris.) "Me, I get an order, I execute it. You can make fifty thousand abstract paintings, or others in that vein, or *tachistes*, even if the painting is green, well then! the 'subject' is the green. There is always a subject; it's a joke to suppress the subject, it's impossible. It's as if you said: 'Do as if I weren't there.' Try it." (Parmelin, 1965, page 127)

The Picture as a Sum of Destructions

"In the old days pictures went forward toward completion by stages. Every day brought something new. A picture used to be a sum of additions. In my case a picture is a sum of destructions. I do a picture—then I destroy it. In the end, though, nothing is lost: the red I took away from one place turns up somewhere else." (Zervos, 1935)

———

"The important thing is to do, and nothing else; be what it may."

"But then, what do you do when the picture is finished?"

"Have you ever seen a finished picture? A picture or anything else? Woe unto you the day it is said that you are finished! To finish a work? To finish a picture? What nonsense! To finish it means to be through with it, to kill it, to rid it of its soul, to give it its final blow: the most unfortunate one for the painter as well as for the picture." (Sabartés, 1946, page 146)

"Unfinished, a picture remains alive, dangerous. A finished work is a dead work, killed." (Haesaerts, 1961, page 7)

After Clouzot completed his film *The Miracle of Picasso*, Picasso said: "No, one doesn't stop by oneself. You work and behind you stands somebody who is not a professional and it is he who makes the decisions: this is all right, this is bad . . . a kind of guardian angel who stops you from continuing to paint." (*Der Spiegel*, 1956)

However, to guard against giving the impression that he was working with the hope of ultimate perfection, he added: "Pictures are

never finished in the sense that they suddenly become ready to be signed and framed. They usually come to a halt when the time is ripe, because something happens which breaks the continuity of their development. When this happens it is often a good plan to return to sculpture." And to express his satisfaction in changing to another medium, he added: "After all, a work of art is not achieved by thought but with your hands." (Penrose, 1958, page 352)

"The main thing about modern painting," says Picasso, "is this. A painter like Tintoretto, for example, begins work on a canvas, and afterward he goes on and, finally, when he has filled it and worked it all over, then only is it finished. Now, if you take a painting by Cézanne (and this is even more clearly visible in the watercolors), the moment he begins to place a stroke of paint on it, the painting is already there." (Parmelin, 1965, page 150)

First Vision Intact

"But there is one very odd thing—to notice that basically a picture doesn't change, that the first 'vision' remains almost intact, in spite of appearances." (Zervos, 1935)

===========

"All the interest in art lies in the beginning. After the beginning, it's already the end." (Tériade, 1932)

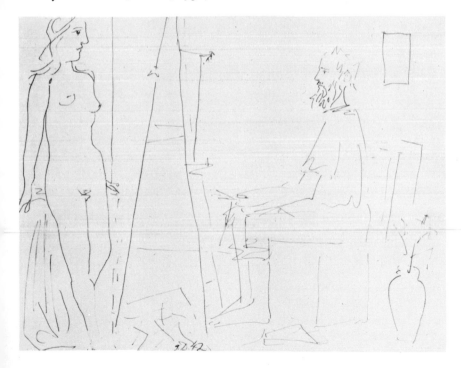

A Painter Paints to Unload Himself

"The painter goes through states of fullness and evacuation. That is the whole secret of art, I go for a walk in the forest of Fontainebleau. I get 'green' indigestion. I must get rid of this sensation into a picture. Green rules it. A painter paints to unload himself of feelings and visions." (Zervos, 1935)

―――――

"We are not merely the executors of our work; we *live* our work." (Penrose, 1951)

"The artist goes through states of fullness and emptiness, and that is all there is to the mystery of art." (Picasso, 1954)

"Primarily a work has the value we put into it. At one time it was Michelangelo's *The Last Judgment*, nowadays it's a 'canvas.' Works arise according to the moment, place and circumstances."
"Fundamentally one always interprets the real, and everything is grist to the artist's mill. Everything is a starting point. One swallows something, is poisoned by it and eliminates the toxic." (Conversation of February 26, 1956) (Souchère, 1960, pages 5–6)

". . . You're a painter, too, so you know how it goes. We can give ourselves the worse kind of trouble over our canvases, and tear our hair out, without anyone asking us to. On the contrary, nobody gives a damn whether we're doing one thing or another. And we always make the worst choice, even when we know they'd prefer a bouquet of flowers. In any case, they won't like what we do. And even if they do like it, you can be sure it won't be at all because of the painting.

But, after all, we, the painters, have worked, and that's already some-
thing, and we're satisfied. Then we go out for a walk or a ride, and we
paint a landscape or a fellow making music. Why? Why that, instead
of Notre-Dame? Or a portrait of my parrot? I'll tell you why. It's
because, at the moment we're doing it, it makes us feel better. And
that's the main thing." (Parmelin, 1969, page 8)

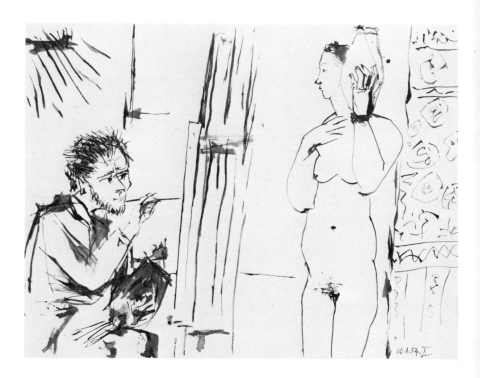

The Artist's Personality

"It's not what the artist *does* that counts, but what he *is*. Cézanne would never have interested me a bit if he had lived and thought like Jacques Émile Blanche, even if the apple he painted had been ten times as beautiful. What forces our interest is Cézanne's anxiety— that's Cézanne's lesson; the torments of Van Gogh—that is the actual drama of the man. The rest is a sham." (Zervos, 1935)

"Actually, everything depends on oneself. It's the sun in the belly with a million rays. The rest is nothing. It's only for that reason that Matisse is Matisse—it's because he carries the sun in his belly. And it's also the reason why, from time to time, something happens. The oeuvre one creates is a form of diary." (Tériade, 1932)

In an essay published in 1935 in the Madrid magazine *Cruz y Raya*, Jaime Sabartès quotes Picasso as saying to a young painter: "If you want to draw a circle and claim to be original, don't try to give it a strange form which isn't exactly the form of a circle. Try to make the circle as best you can. And since nobody before you has made a perfect circle, you can be sure that your circle will be completely your own. Only then will you have a chance to be original." (Parrot, 1948, pages 12–13)

When I remarked that there were several errors in spelling he replied impassively: "So what? From errors one gets to know the personality! If I were to start correcting the mistakes you mention in accordance with rules which have nothing to do with me, whatever is personal in my writings would be lost in a grammar which I have not

assimilated. I would prefer to invent a grammar of my own than to bind myself to rules which do not belong to me." (Sabartés, 1946, page 119)

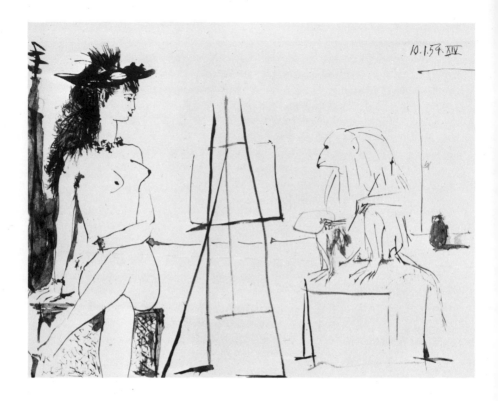

On another occasion he talked to me about originality in approximately the following words:

"If you look carefully you can find a peseta almost anywhere; but personality cannot be found, no matter how much you look for it, for it resides within the person himself. If you think about it you will see that this is not a play on words. Personality does not emanate from the desire to be personal. The individual who insists on being original wastes his time and deceives himself; if he attains something it is but an imitation of what he likes, and if he goes farther it may be that what he does does not even resemble him. One day I told Angel

Ortiz: to make a circle without a compass, try to trace a line always equidistant from the center, but do not think about other forms or about the many people who have traced circles before you. If you kill yourself, you will not make it perfectly round; and in the discrepancy between perfect roundness and your closest approximation to it, you will find your personal expression. If you work in good faith you will try to make it perfect, but each of your circles, in spite of your improved dexterity in drawing them will always suffer from the same defect. Every one of them will bear your mark. But if, suddenly, you decide to imitate somebody else, you'll do it worse, and your deception will fool only morons." (Sabartés, 1946, pages 208–209)

Picasso says: "The inner I is inevitably in my painting, since it is I who make it. I needn't worry about that. Whatever I do, it will be there. It will be all too much there. . . . It's the rest that is the problem! (Parmelin, 1965, page 106)

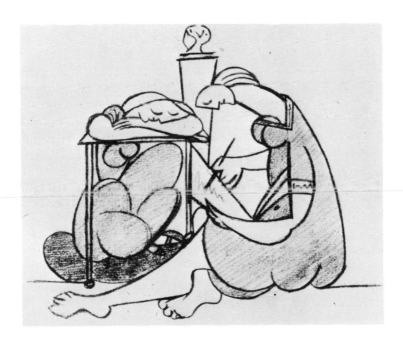

Picasso says: "The awful thing is that one is one's own Promethean eagle, both the one who devours and the one who's devoured." (Parmelin, 1966, page 140)

Picasso says: "What I find horrible nowadays is that people are always trying to find a personality for themselves. Nobody bothers about what you might call a painter's ideal . . . the kind that's always existed (I say ideal because that's what comes nearest to it). No. They couldn't care less about that.

"All they're trying to do is to make the world a present of their personality. It's horrible.

"Besides, if you're trying to find something, it means you haven't got it. And if you find it simply by looking for it, that means it's false.

"For my part, I can't do anything else but what I am doing." (Parmelin, 1969, page 101)

The Necessity of Work

"Work is a necessity for man.
 "A horse does not go between the shafts of its own accord.
 "Man invented the alarm clock." (Zervos, 1935)

"I paint the way someone bites his fingernails; for me, painting is a bad habit because I don't know nor can I do anything else." (Gallego Morell, 1958, page 3)

"But worst of all," says Picasso, "is that he never finishes. There's never a moment when you can say, 'I've worked well and tomorrow is Sunday.' As soon as you stop, it's because you've started again. You can put a picture aside and say you won't touch it again. But you can never write THE END." (Parmelin, 1966, pages 67–68)

"Where do I get this power of creating and forming? I don't know. I have only one thought: work.
 "I paint just as I breathe. When I work, I relax; not doing anything or entertaining visitors makes me tired. It's still often 3:00 a.m. when I switch off my light." (Beyeler, 1968, page 124)

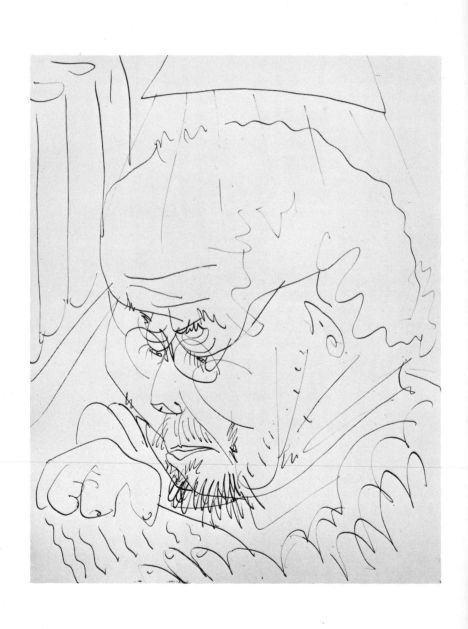

Imitation and Imitators

"Where things are concerned there are no class distinctions. We must pick out what is good for us where we can find it—except from our own works. I have a horror of copying myself. But when I am shown a portfolio of old drawings, for instance, I have no qualms about taking anything I want from them." (Zervos, 1935)

"Sure," she [Gertrude Stein] said, "as Pablo once remarked, when you make a thing, it is so complicated making it that it is bound to be ugly, but those that do it after you they don't have to worry about making it and they can make it pretty, and so everybody can like it when others make it." (Stein, 1933, page 23)

"Copiers don't bother me provided that they copy frankly and not for too long a time: if they have any temperament, it'll appear eventually to disclose the personality of an artist. The best means is to make him draw a perfect circle. He won't succeed, but this failed circle will reveal his temperament. Or ask him to copy a painting. His copy will not be exactly like the model, but something that belongs to him will appear. They said when I began in Paris that I copied Toulouse-Lautrec and Steinlen. Possible, but never was a painting by Toulouse-Lautrec or Steinlen taken for mine. It is better to copy a drawing or painting than to try to be inspired by it, to make something similar. In that case, one risks painting only the faults of his model. A painter's atelier should be a laboratory. One doesn't do a monkey's job here: one invents. Painting is a *jeu d'esprit*." (Warnod, 1945)

"Ha!" exclaimed Picasso, "do you think I paint for those people at the Rotonde? . . . It's too bad if they're still there, let them walk in their own shit. Since I now have imitators I couldn't care less."

"Imitators?"

"All right! Disciples if you like. But disciples be damned. It's not interesting. It's only the masters that matter. Those who create. And they don't even turn around when you piss on their heels. . . ." (Georges-Michel, 1954, pages 94–95)

"Oh! no," exclaimed Picasso. "Don't expect me to repeat myself. My past doesn't interest me any more. I would rather copy others than repeat myself. At least I would inject something new into them. I like discovering too much." (Georges-Michel, 1954, page 100)

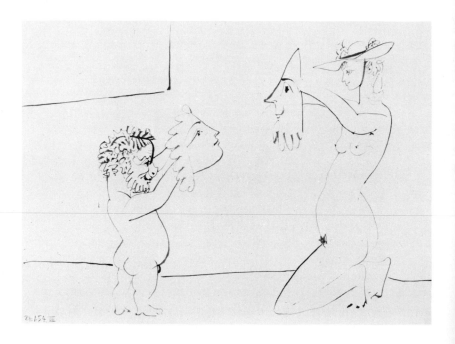

"Why should one stick desperately to everything that has fulfilled its promise?

"Would you have a man only able to repeat himself? Repetition is contrary to the laws of the spirit, to its flight forward!

"Copying others is necessary, but what a pity to copy oneself!" (Souchère, 1960, page 27)

"What does it mean," says Picasso, "for a painter to paint in the manner of So-and-So or to actually imitate someone else? What's wrong with that? On the contrary, it's a good idea. You should constantly try to paint like someone else. But the thing is, you can't! You would like to. You try. But it turns out to be a botch. . . .

"And it's at the very moment you make a botch of it that you're yourself." (Parmelin, 1965, page 43)

Respect for Painters

"I have never in any museum seen a picture as beautiful as this one," he said to me, pointing to a sheet of tin hanging on the door. "The man who painted this picture was not thinking of his glory."

He was referring to a sign painted upon the sheet of tin. Time, rain, and dust, aided by the wind, had besmirched it. Now the setting sun seemed to be kissing its faded forehead. Against the bluish gray of the tin, the letters were scarcely visible, but the metal background glistened in the sunlight so that even the mud seemed to shine.

"Do you really think that this picture merits the honors of a museum?"

"Why not," he answered, "you'll find even worse things than this in museums."

"Do you mean that there are better ones and that this one would not in any case rank among the good ones?"

"You are carrying it too far! . . . When I was discussing the sign, I was thinking about the painter who did the lettering, and not about the result. If it resists mud, so much the better: that proves its worth. Museums content themselves with the dust of the hands, and the tricks, the patina of time, because it is written that one must respect old age. But deprive the pictures of all this and you will see what is left. The painter contributed all that was his: the time, the place, and state of mind do the rest, as in this case. But I am interested only in the painter's work because, thanks to it, I can see him and I am certain that the poor devil put all his five senses into producing it. (Sabartés, 1946, pages 210–212)

Notre Dame de Vie
20 October 1961

PICASSO: I like all painting. I always look at the paintings—good or bad—in barbershops, furniture stores, provincial hotels. . . . I'm like a drinker who needs wine. As long as it's wine, it doesn't matter which wine. (Guttuso, 1964)

It is not a question of good painters and bad painters: he loves all painters—or almost all; and he respects them even in their errors. Because in this vocation, he says, there is "a kind of madness that deserves to be taken into consideration. Even if it's a question of a landscape with ducks or, on the contrary, of a brushstroke on top of another brushstroke." (Parmelin, 1965, page 142)

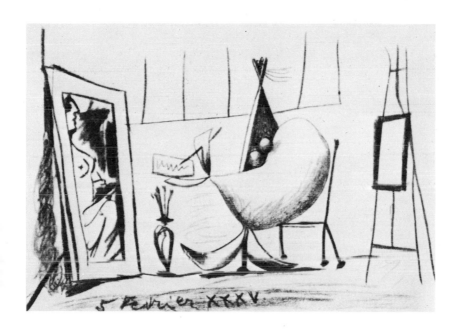

Young Artists

"With the exception of a few painters who are opening new horizons to painting, young painters today don't know which way to go. Instead of taking up our researches in order to react clearly against us, they are absorbed with bringing the past back to life—when truly the whole world is open before us, everything waiting to be done, not just redone. Why cling desperately to everything that has already fulfilled its promise? There are miles of painting 'in the manner of'; but it is rare to find a young man working in his own way.

"Does he wish to believe that man can't repeat himself? To repeat is to run counter to spiritual laws; essentially escapism." (Zervos, 1935)

—————

"You ask me what I think of the young? There are young people and young people. . . . Youth has no age. . . . There are some young ones who are older than some artists dead several centuries. Naturally, it's necessary that they should start with their own time, with modern art, of course. There is no reason why, having an automobile at their disposal, they should start riding horses or bicycles. Above all not under the pretext that there is a special way of locomotion for eighteen years, twenty years and thirty years old. . . . The important thing is that they start out with what belongs to them, is in them, and not with that which belongs to others or with what others discovered.

"What is taught at the Ecole des Beaux-Arts has only to do with craft and not with painting. It's the same as to learn how to produce shoes. . . . And the shoes produced by one of the students couldn't even be worn!" (Jakovsky, 1946, page 8)

George-Henri Adam, who sees Picasso often, has relayed to me some of the painter's comments on the problems facing young artists today: "A large number of young painters show me their pictures. Why do they want to retrace my path? Why do they adopt the old formulas of cubism, fauvism and impressionism? Almost all of them seem to me destined to become *painters of charm*. For the most part, they only popularize the techniques of those who preceded them: the dealers, who rejected the latter, today encourage their imitators. The eye of the public has grown used to them. The young painters ask themselves questions. They pose artistic problems to themselves even before waiting for these problems to be posed. It's a great tragedy for young painters to look for artistic problems in this way. They stop en route; all their vitality is paralyzed. They draw on memories and allusions, and try to find a way to solve this difficulty which they themselves have unwisely created with methods that have already

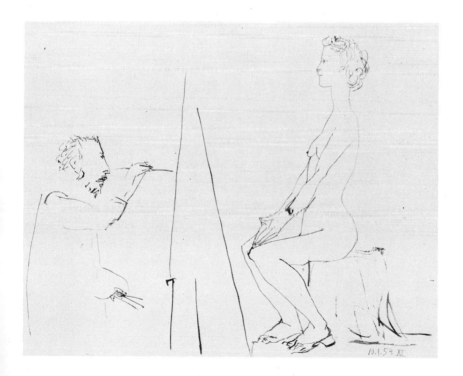

10.1.54.XI

proved their worth. Let them never stop en route! A growing tree does not pose itself problems of tree-culture. A young artist must forget painting when he paints. That's the only way he will do original work. To blossom forth, a work of art must ignore, or rather forget all the rules." (Parrot, 1948, page 12)

IV

Cubism

"Cubism is no different from any other school of painting. The same principles and the same elements are common to all. The fact that for a long time cubism has not been understood and that even today there are people who cannot see anything in it, means nothing. I do not read English, an English book is a blank book to me. This does not mean that the English language does not exist, and why should I blame anybody else but myself if I cannot understand what I know nothing about?" (De Zayas, 1923)

"Many think that cubism is an art of transition, an experiment which is to bring ulterior results. Those who think that way have not understood it. Cubism is not either a seed or a foetus, but an art dealing primarily with forms, and when a form is realized it is there to live its own life." (De Zayas, 1923)

"Cubism has kept itself within the limits of limitations of painting, never pretending to go beyond it. Drawing, design and color are understood and practiced in cubism in the spirit and manner that they are understood and practiced in all other schools. Our subjects might be different, as we have introduced into painting objects and forms that were formerly ignored. We have kept our eyes open to our surroundings, and also our brains." (De Zayas, 1923)

"The goal I proposed myself in making cubism? To paint and nothing more. And to paint seeking a new expression, divested of

useless realism, with a method linked only to my thought—without enslaving myself or associating myself with objective reality. Neither the good or the true; neither the useful or the useless. It is my will that takes form outside of all extrinsic schemes, without considering what the public or the critics will say." (Del Pomar, 1932, page 126)

Julio Gonzales, speaking of Picasso's 1908 cubist paintings: "These paintings—all you would have to do is to cut them apart, the colors being only indications of different perspectives, of inclined planes from one side or the other. Then you could assemble them according to the indications given by the color and find yourself in the presence of 'sculpture.' " (Gonzales, 1936)

"Thus when we (Picasso and his Cubist friends) used to make our constructions, we produced 'pure truth,' without pretensions, without tricks, without malice. What we did then had never been done before: we did it disinterestedly, and if it is worth anything it is because we did it without expecting to profit from it. We sought to express reality with materials we did not know how to handle and which we prized precisely because we knew that their help was not indispensable to us, that they were neither the best nor the most adequate. We put enthusiasm into the work, and this alone, even if that were all that were in it, would be enough: and much more than is usually put into an effort—for we surrendered ourselves to it completely, body and soul. We departed so far from the modes of expression then known and appreciated that we felt safe from any suspicion of mercenary aims." Sabartés, 1946, page 212)

At Picasso's in Paris,
July 3, 1952

PICASSO: The other day I walked through the rue St. Denis, it's marvelous!

KAHNWEILER: Oh, you've seen it! I often pass through there when walking home. It's so extremely beautiful, all the girls lined up along the sidewalk, and everything!

PICASSO: Yes, it's beautiful, the girls, the hawkers, the flowers: it's

splendid! I said to myself: Certainly, a glass and a package of ciga-
rettes, they're beautiful and it's also as difficult as the Last Judgment
but, all the same, if one could do that, a city's life, that would be
magnificent! But one couldn't do it all by oneself, one had to be with
others, as in the past with cubism, it needs the work of a team.
(Kahnweiler, 1952)

"Cubism?" I asked.
"I saw that everything had been done. One had to break to make
one's revolution and start at zero. I made myself go towards the new
movement. The problem is now to pass, to go around the object, and
give a plastic expression to the result." He looked around him and
said: "All of this is my struggle to break with the two-dimensional
aspect." (Liberman, 1956)

Braque found that the rectangular composition often became irk-
some towards the corners of the canvas and often enclosed his pic-
tures as an oval. A rectangular composition within a rectangle was
dull, it led nowhere; whereas placed in an oval—which, as Picasso
recently pointed out to me, can signify a circular plane seen in per-
spective—the whole picture gained a three-dimensional effect. One of
Picasso's earliest oval pictures is a nude dating from 1910.* In it the

* See Zervos, *Picasso*, Vol. II, p. 114, No. 228.

total effect of the picture is almost spherical. "In the early days of cubism," he told me, "we made experiments, the squaring of the circle was a phrase that excited our ambitions . . . to make pictures was less important than to discover things all the time"—but he warned me again not to think it was ever a question of exact calculations. The aim was rather to create space in a convincing way and therefore a new reality. For this reason, he said, he had always hoped to make a painting that was literally spherical. . . . (Penrose, 1958, page 160)

"Moreover, to know that we were doing cubism we should have had to be acquainted with it! Actually, nobody knew what it was. And if we had known, everybody would have known. Even Einstein did

not know it either! The condition of discovery is outside ourselves; but the terrifying thing is that despite all this, we can only find what we know. Cubism was a work of patience, and a very complicated work too. It requires thousands of workers to accomplish a thing like that. That is the true story." (Souchère, 1960, page 15)

Picasso said to me in those days, "Of course, when I want to make a cup, I'll show you that it is round, but the over-all rhythm of the painting, the structure, may force me to show this roundness as a square." (Kahnweiler, 1961, page 57)

Lionel Prejger speaks of a strange sketch on wrapping paper for one of the cut metal sculptures. Picasso tells him: "It's a chair, and you see, that it is an explanation of cubism! Imagine a chair passed under the rollers of a compressor—it would turn out just about like that." (Prejger, 1961, page 29)

Figurative, Nonfigurative, Abstract

"And from the point of view of art there are no concrete or abstract forms, but only forms which are more or less convincing lies. That those lies are necessary to our mental selves is beyond any doubt, as it is through them that we form our aesthetic point of view of life." (De Zayas, 1923)

———

"Nor is there any 'figurative' and 'nonfigurative' art. Everything appears to us in the guise of a 'figure.' Even in metaphysics ideas are expressed by means of symbolic 'figures.' See how ridiculous it is then to think of painting without 'figuration.' A person, an object, a circle are all 'figures'; they react on us more or less intensely." (Zervos, 1935)

———

"Abstract art is only painting. What about drama?
"There is no abstract art. You must always start with something. Afterward you can remove all traces of reality. There's no danger then, anyway, because the idea of the object will have left an indelible mark. It is what started the artist off, excited his ideas, and stirred up his emotions. Ideas and emotions will in the end be prisoners in his work. Whatever they do, they can't escape from the picture. They form an integral part of it, even when their presence is no longer discernible." (Zervos, 1935)

———

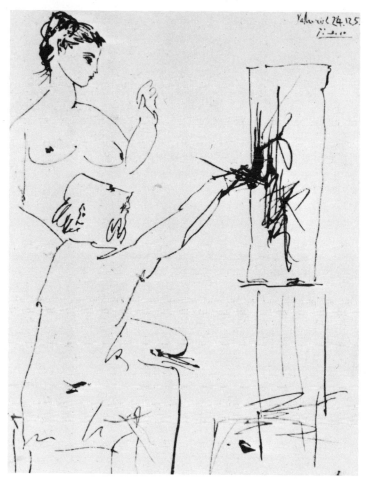

Asked if art should be abstract, he replied: "No. Unaffected, simple, direct. It is like a bridge. What would be the best bridge? Well, the one which could be reduced to a thread, a line, without anything left over; which fulfilled strictly its function of uniting two separated distances." (Giménez Caballero, 1935, page 47)

Picasso, not liking Gertrude Stein's word portrait of him, said he just didn't like abstractions. (Rönnebeck, 1944)

"Raphael's image of a woman is only a sign. A woman by Raphael is not a woman, it's a sign that in his spirit and ours represents a woman. If this woman is decorated with an aureole, and if she has a child on her knees, then she's a Virgin. All that's only a sign. We understand that this sign represents a woman because it can't represent a house or a tree. I'll show you something odd, à propos."

Picasso leaves a moment, and returns with an object in iron; a statuette representing a woman in some archaic civilization, or perhaps Negro, but a very modern conception. A flat head, long center of the circle a smaller circle pierced with holes which could be breasts and below, two legs which support the whole.

"What would you call it? I'd call it 'The Venus of the Gas Company.'"

"Why?"

"Because the object I'm showing you isn't a statuette. It's a simple part of my gas meter. You'd probably find the same in your kitchen."

"I admit I was fooled."

"Why fooled? This object could very well be the sign of a woman, and the lines and volumes are harmonious. It sufficed to discover them." (Warnod, 1945)

"I paint only what I see. I've seen it, I've felt it, maybe differently from other epochs in my life, but I've never painted anything but what I've seen and felt. The way a painter paints is like his writing for graphologists. It's the whole man that is in it. The rest is literature, the business of commentators, of critics." (Jakovsky, 1946)

Rome, 1949

To a friend who asked if, after all the figurative painting of the past, it was worth painting figuratively:

PICASSO: I've always known that with the grape you make wine. The contrary has never occurred. (Guttuso, 1964)

Picasso never intended to paint "abstractions" in order to agreeably tickle the nerves of some aesthetes. Talking about a series of small landscapes of the Cité, painted a year previously and delighting certain visitors to his studio, visitors resistant to his figures, he told me on November 9, 1944: "Naturally, they're exactly the same as my nudes or my still-lifes, but in my figures people see the nose that is askew whereas nothing would shock them looking at a bridge. But this 'askew nose' was painted that way expressly. You understand me: I did it in such a way that they were *obliged* to see a nose. Later on, they'll have seen, or will see that the nose was not askew. What had to be avoided was their continuing to see nothing else but 'nice harmonies,' 'exquisite colors.' " (Kahnweiler, 1951, page 2, page 7)

PICASSO: "I always aim at the resemblance. An artist should observe nature but never confuse it with painting. It is only translatable into painting by signs." (Brassaï, 1966, page 162)

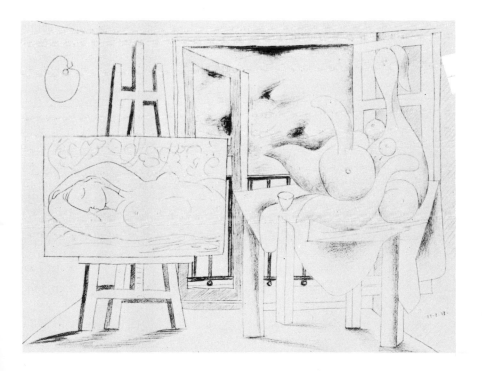

Picasso comes to the chapter in the album titled "The Language of Walls." He is surprised by the great brushstrokes of paint, effacing the inscriptions on the wall.

PICASSO: "You did well to photograph that . . . because it's a good demonstration of the nature and limits of abstract art. These brushstrokes are very beautiful . . . but it is a natural beauty. A few strokes of a brush that have no meaning will never make a picture. I do this sort of thing myself, and occasionally you might say it was an abstract. But my brushstrokes always signify something: a bull, an arena, the sea, the mountains, the crowd. . . . To arrive at abstraction, it is always necessary to begin with a concrete reality. . . . Art is a language of symbols. When I pronounce the word 'man,' I call up a picture of man; the word has become the symbol of man. It does not represent him as photography could. Two holes—that's the symbol for the face, enough to evoke it without representing it. . . . But isn't it strange that it can be done through such simple means? Two holes; that's abstract enough if you consider the complexity of man. . . . Whatever is most abstract may perhaps be the summit of reality. . . ." (Brassaï, 1966, page 241)

Ansermet remembers being amazed by the rapidity with which, even during a bullfight, Picasso could switch from a naturalistic to a cubist style of drawing, and when he asked him how he managed it, Picasso replied quite simply, "But can't you see that the result is the same? It's the same bull only seen in a different way." (Cooper, 1968, page 31)

Modern Art

When Albert Junyent remarked on recent attacks on modern art based on a failing market, Picasso exclaimed: "Let them say what they will. Economic arguments are not valid. After all, isn't it also difficult to sell automobiles, champagne, or even the other, the 'official' paintings?

"I who have been involved with all styles of painting can assure you that the only things that fluctuate are the waves of fashion which carry the snobs and speculators; the number of true connoisseurs remains more or less the same. . . .

"In terms of laboratory research, the search has been thorough and intensive. Our epoch could not go any further. Certainly we have achieved a profound break with the past. The proof that the revolution has been radical is demonstrated by the fact that the words expressing fundamental concepts—drawing, composition, color, quality—have completely changed meaning." (Junyent, 1934)

Painting as Research

"I can hardly understand the importance given to the word *research* in connection with modern painting. In my opinion to search means nothing in painting. To find, is the thing. Nobody is interested in following a man who, with his eyes fixed on the ground, spends his life looking for the pocketbook that fortune should put in his path.

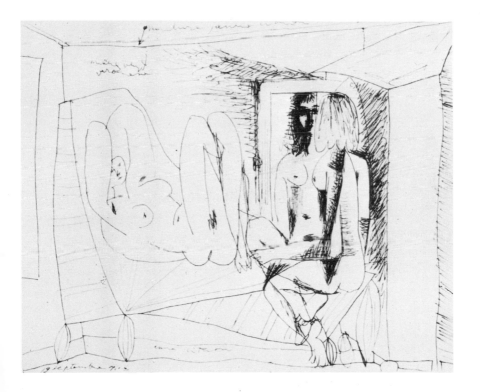

The one who finds something, no matter what it might be, even if his intention were not to search for it, at least arouses our curiosity, if not our admiration.

"Among the several sins that I have been accused of committing, none is more false than the one that I have, as the principal objective in my work, the spirit of research. When I paint, my object is to show what I have found and not what I am looking for. In art intentions are not sufficient and, as we say in Spanish: love must be proved by facts and not by reasons. What one does is what counts and not what one had the intention of doing." (De Zayas, 1923)

"I have a horror of people who speak about the beautiful. What is the beautiful? One must speak of problems in painting!

"Paintings are but research and experiment.

"I never do a painting as a work of art. All of them are researches. I search incessantly and there is a logical sequence in all this research. That is why I number them. It's an experiment in time. I number them and date them. Maybe one day someone will be grateful," he added laughingly. (Liberman, 1956)

V

Beauty

"Academic training in beauty is a sham. We have been deceived, but so well that we can scarcely get back even a shadow of the truth. The beauties of the Parthenon, Venuses, Nymphs, Narcissuses, are so many lies. Art is not the application of a canon of beauty but what the instinct and the brain can conceive beyond any canon." (Zervos, 1935)

———

"Beauty," he said, "is something strange, don't you find? To me it is a word without sense because I do not know where its meaning comes from or where it leads to. Do you know exactly where its opposite is to be found? If someone were to show me that there exists a positive ugliness, that would be something else. Of course, I know very well what they would tell me; for after all, these words are bogy men to frighten the children of the art schools and the rest. The Academy devised the formula; not long ago they submitted the senses to the 'official' judgment of what is beautiful and what is ugly. The Renaissance invented the size of noses. Since then reality has gone to the devil." (Sabartés, 1946, page 206)

"Have you ever seen anything more beautiful than that old woman? . . . I am sure that she has never washed. . . . There you have an honest-to-goodness old woman! She powders herself with dust. *Sembla un bolet d'aquest terrer.* (She looks like a mushroom that has grown out of the spot.) How Velázquez would have loved to meet her! One should paint her exactly as she is. Underneath she is just like everybody else, but she belongs to the school on filth. See how she laughs because we're looking her over. 'Good evening. . . . How do

you do? Getting along? . . . Good, very good. . . . We'll see you tomorrow. . . . Yes, indeed. . . . until tomorrow. . . .'" (Sabartés, 1946, page 208)

Notre Dame de Vie
February 2, 1964

PICASSO: Braque once said to me: "Basically you have always loved classical beauty." It's true. Even today that's true for me. They don't invent a type of beauty every year. (Guttuso, 1964)

Freedom

"Freedom," says Picasso, "one must be very careful with that. In painting as in everything else. Whatever you do, you find yourself once more in chains. Freedom not to do one thing requires that you do another, imperatively. And there you have it, chains. That reminds me of a story of Jarry about the anarchist soldiers at drill. They are told: right face. And immediately, since they are anarchists, they all face left. . . . Painting is like that. You take freedom and you shut yourself up with your idea, just that particular one and no other. And there you are again, in chains." (Parmelin, 1965, page 170)

Still on the subject of freedom and the chains it implies, Picasso explodes and says: "They explain to you that children must be allowed freedom. In fact, they are forced to make children's drawings. They teach them to do them. They have even taught them to do children's drawings that are abstractions. . . .

"In fact, as usual under the pretext of leaving them free, above all of not thwarting them, they close them within their *genre*, with their chains." (Parmelin, 1965, page 176)

Picasso says: "If I stick three pieces of wood on a poster and if I say: that's painting, it's not freedom, in what way is it freedom? It's a matter of doing any old thing with three pieces of wood. . . . If there's a single freedom in what one does, it's the freeing of something within oneself. And even that doesn't last." (Parmelin, 1966, page 67)

Genius

Talking about genius he said: "It is personality with a penny's worth of talent. Error which, by accident, rises above the commonplace." (Sabartés, 1946, page 209)

———

"Contrary to what sometimes happens in music, miracle children do not exist in painting. What might be taken for a precocious genius is *the genius of childhood*. When the child grows up, it disappears without a trace. It may happen that this boy will become a real painter some day, or even a great painter. But then he will have to begin everything again, from zero. As for me, I didn't have this genius. My first drawings could never be exhibited in an exposition of children's drawings. The awkwardness and naïveté of childhood were almost absent from them. I outgrew the period of that marvelous vision very rapidly. At that boy's age I was making drawings that were completely academic. Their precision, their exactitude, frightens me. My father was a professor of drawing, and it was probably he who pushed me prematurely in that direction. . . ." (Brassaï, 1966, page 86)

AVANT-PROPOS

Love

"In the end, there is only love. However it may be. And they ought to put out the eyes of painters as they do goldfinches in order that they can sing better." (Tériade, 1932)

Picasso often said that painting is a blind man's profession. (Cocteau, page 49)

Picasso is opening a bottle of anise brought by Cela: "One has to be careful not to break the banderole! . . . You have to take objects seriously. And lovingly; this one, very lovingly. Everything else is tricks."

(This reminds Cela of Picasso's famous remark about love being at the heart of everything; that they should put out painters' eyes as they do goldfinches' eyes so that they may sing more sweetly.) (Cela, 1960)

Perfectionism

He said that when one went to an exhibition and looked at the pictures of the other painters one knows that they are bad, there is no excuse for it they are simply bad, but one's own pictures, one knows the reasons why they are bad and so they are not hopelessly bad. (Stein, 1959, page 9)

"A tenor who hits a note higher than that written in the score— I!" (*Carnet Catalan*, 1958, page 40)

"I'm always saying to myself: 'That's not right yet. You can do better.' It's rare when I can prevent myself from taking a thing up again . . . x number of times, the same thing. Sometimes, it becomes an absolute obsession. But for that matter, why would anyone work, if not for that? To express the same thing, but express it better. It's always necessary to seek for perfection. Obviously, for us, this word no longer has the same meaning. To me, it means: from one canvas to the next, always go further, further. . . ." (Brassaï, 1966, page 85)

Poverty

In reply to a sculptor who had said, "You are too fond of poverty, Picasso," he said, "I'm fond of poverty! If it weren't so costly, I'd treat myself to it." (Ponge, 1960)

Reality

Robert Desnos, formerly a surrealist, had written brilliantly about Picasso more than ten years before. In his last essay before he died he recounts a story Picasso told him: "I had lunched at the Catalan for months," Picasso said, "and for months I looked at the sideboard without thinking more than 'It's a sideboard.' One day I decide to make a picture of it. I do so. The next day, when I arrived, the sideboard had gone, its place was empty. . . . I must have taken it away without noticing by painting it." "An amusing story, of course," Desnos remarks, "in spite of or rather because of its veracity; but it illustrates like a fable or a proverb the relationship between the work and the reality. For Picasso what matters, when he paints, is 'to take possession' and not provisionally like a thief or a buyer, just for a lifetime, but as himself the creator of the object or of the being." (Penrose, 1958, page 312)

Cannes, La Californie
9.11.1959

". . . That's the marvelous thing with Frenhofer in the *Chef d'Oeuvre Inconnu* by Balzac. At the end, nobody can see anything except himself. Thanks to the never-ending search for reality, he ends in black obscurity. There are so many realities that in trying to encompass them all one ends in darkness. That is why, when one paints a portrait, one must stop somewhere, in a sort of caricature. Otherwise there would be nothing left at the end." (Kahnweiler, 1959)

"Any form which conveys to us the sense of reality is the one which is furthest removed from the reality of the retina; the eyes of

the artist are open to a superior reality; his works are evocations." [Conversation of 23 May 1954] (Souchère, 1960, page 23)

One day he said: "Reality is a word that lies around everywhere. It's found in every sauce. The strangest thing is that nothing is done if not in its name.

"From cliché to more cliché, from 'modernistic' to more 'modernistic' (or what considers itself 'modernistic')—even that is called reality. Strange. Even when one says one has managed to dispense with it." (Parmelin, 1965, page 94)

Picasso says: "It's no longer the reality that must enter my form. Otherwise I'm like a pastry cook who makes molds, and I make all sorts of dough in order to put it into molds. 'That one's with ginger and that one's with pistachio.' And after that you no longer dare set foot outside your mold." (Parmelin, 1966, page 68)

Solitude

"Nothing can be done without solitude. I've created my own solitude which nobody suspects. It's very difficult nowadays to be alone because we all own watches. Have you even seen a saint with a watch? Yet, I've looked everywhere for one even amidst the saints known as patrons of the watchmakers." (Tériade, 1932)

===

"Because I cannot work except in solitude," he continued. "It is necessary that I live my work and that is impossible except in solitude." (Salles, 1964, page 271)

Picasso was looking at an extraordinary canvas, a *Château Noir* by Cézanne, which formed part of his collection.

He said: "And those men lived in unbelievable solitude which was perhaps a blessing to them, even if it was their misfortune too. Is there anything more dangerous than sympathetic understanding? Especially as it doesn't exist. It's almost always wrong. You think you aren't alone. And really you're more alone than you were before." (Parmelin, 1969, page 114)

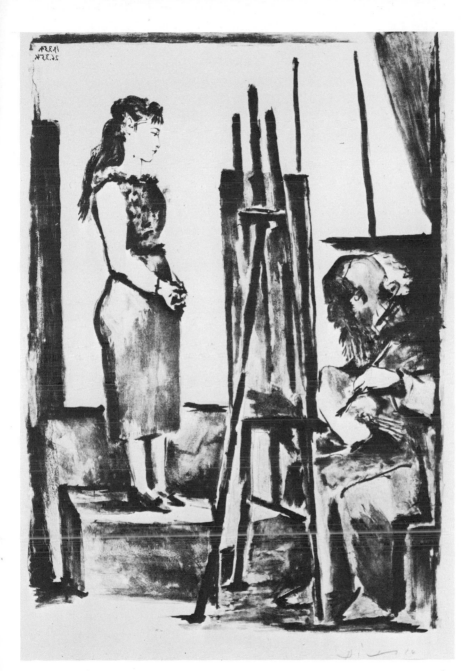

Success

Very much later when he had had a great deal of success he said one day, you know, your family, everybody, if you are a genius and unsuccessful, everybody treats you as if you were a genius, but when you come to be successful, when you commence to earn money, when you are really successful, then your family and everybody no longer treats you like a genius, they treat you like a man who has become successful. (Stein, 1959, page 27)

———

Gertrude Stein says "once everybody knows they are good the adventure is over." Picasso adds with a sigh, "even after everybody knows they are good not any more people really like them than they did when only the few knew they were good." (Stein, 1933, page 88)

"Success is dangerous. One begins to copy oneself, and to copy oneself is more dangerous than to copy others. It leads to sterility," and with a smile he added, "to make oneself hated is more difficult than to make oneself loved." (Liberman, 1956)

"Of all—hunger, misery, the incomprehension by the public—fame is by far the worst. It is the castigation by God of the artist. It is sad. It is true." (Duncan, 1961, page 74)

PICASSO: "But success is an important thing! It has often been said that an artist should work for himself, for the love of art, and scorn success. It's a false idea. An artist needs success. Not only in order to live, but primarily so that he can realize his work. Even a rich painter

should know success. Few people understand much about art, and not everyone is sensitive to painting. The majority judges a work of art in relation to its success. So why leave success to 'successful painters'? Each generation has them. But where is it written that success must always go to those who flatter the public taste? For myself, I wanted to prove that success can be obtained without compromise, even in opposition to all of the prevailing doctrines. Do you want me to tell you something? It is the success of my youth that has become my protective wall. The blue period, the rose period—they were the screen that sheltered me. . . ." (Brassaï, 1966, page 132)

VI

Color

"How often haven't I found that, wanting to use a blue, I didn't have it. So I used a red instead of the blue." (Tériade, 1932)

———

"At the actual time that I am painting a picture I may think of white and put down white. But I can't go on working all the time thinking of white and painting it. Colors, like features, follow the changes of the emotions. You've seen the sketch I did for a picture with all the colors indicated on it. What is left of them? Certainly the white I thought of and the green I thought of are there in the picture, but not in the places I intended, nor in the same quantities. Of course, you can paint pictures by matching up different parts of them so that they go quite nicely together, but they'll lack any kind of drama. (Zervos, 1935)

"If you don't know what color to take, take black." (*Popeles de son Armadans*, April 1960)

Picasso answers: "Color? I don't know. Yes, no, yes. Maybe. The same way one puts salt in the soup. No doubt some yellow, a little, some green, very little, they will make the figure look slightly pink. But color interests me less, at the moment, than the 'gravity,' not to say density." (Georges-Michel, 1954, pages 108–109)

Just as his drawings in the drawer were all in black pencil, the original realistic painting was not in color and the majority of the successive studies were in black and white. To Picasso, form and line are all important. He even exclaimed, "Color weakens." (Liberman, 1956)

Surprise and Accident in Art

I asked him why the sight of sea urchins interested him so much, he answered:

"Not much, not little. Like anything else. It isn't my fault that I saw them. Had I seen them only in my imagination I might not have noticed them, even if they had been in front of me. The sense of sight enjoys being surprised. If you pretend to see what is in front of you, you are distracted by the idea in your mind. . . . It's the same law which governs humor. Only the unexpected sally makes you laugh." (Sabartés, 1948, page 29)

On one occasion I met Picasso when I had just left the subway. "I have seen workers removing old posters from the subway and pasting up others," I said. "Some of the surfaces are covered with fragments of previous posters and the effects are beautiful." "Yes," he answered, "nothing is an accident. A man destroys here, puts something there. There is something mysteriously conscious and deliberate that takes place in the mind of the man who pastes and tears those posters. The result is not only accident." (Gonzalez, 1944, page 35)

Looking at one of his paintings he said, "Accidents, try to change them—it's impossible. The accidental reveals man." (Liberman, 1956)

"But I believe that the artist creates. His creation alone is unique. The brushstroke itself is a creative art. When he is at work, but not when he dreams, the forms of the creative artist pass beyond his imagination. When I am dreaming, I do not see anything out of the ordinary. It is the outcome of work which makes the greatest contribution to creation. If we never arrive at this astonishment about our work, we never create new forms." (Souchère, 1960, page 15)

Composition

"Somebody asked me how I was going to arrange my exhibition. I answered: 'Badly.' Because an exhibition, like a picture, well or badly 'arranged,' means the same thing. That which counts is the spirit of continuity of ideas. And when this spirit exists, as in the worst of marriages, everything ends well." (Tériade, 1932)

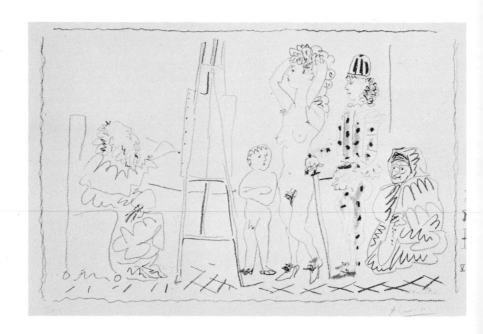

Having gone upstairs with Picasso and Sabartés I find that two of the cubist *Femmes d'Algers* have been considerably changed. The canvas is more fully covered and the color is strengthened.

Picasso: "Yes, I decided to work it over and when I change a little thing I feel impelled to change everything. It's curious, isn't it, because it seems to me that a philosopher can change a word without having to change everything." (Kahnweiler, 1955, *Aujourd'hui*)

Mural Painting

"Do I understand you rightly that you don't see any difference between an easel painting and a fresco?"

"No. Certainly not. There is only good painting and bad painting. Why enlarge something that is already beautiful in small scale? It's the measure of man which makes his greatness and not the size of the canvas. And why wish to decorate at all costs? So that it may stay unchanged in all eternity? The painting on paper has definitely two advantages over the fresco and tapestry: it costs less and it can be changed often." (Jakovsky, 1946)

Style

"Basically I am perhaps a painter without style. Style is often something which locks the painter into the same vision, the same technique, the same formula during years and years, sometimes during

one's whole lifetime. One recognizes it immediately, but it's always the same suit, or the same cut of the suit. There are, nevertheless, great painters with style. I myself thrash around too much, move too much. You see me here and yet I'm already changed, I'm already elsewhere. I'm never fixed and that's why I have no style." (Verdet, 1963)

Titles and Dates

Between visits he spoke to me about the mania of art dealers, art critics, and collectors for christening pictures: some like to give titles to them; others, to change titles. As for him, he never gives any to his works.

"What for? If I paint an apple it should not look like a cat—should it? What more do they want? An apple is an apple. Everybody knows that a still life is a still life, and not a genre painting. When they ask me for a title, I say the first thing that comes into my head." (Sabartés 1946, page 149)

———

Regarding the painting at the Cleveland Museum of Art titled *La Vie*: "It isn't I who gave the painting that title," said Picasso. *"La Vie . . ."* He shrugs his shoulders. "I certainly did not intend to paint symbols; I simply painted images that arose in front of my eyes; it's for the others to find a hidden meaning in them. A painting, for me, speaks by itself; what good does it do, after all, to impart explanations? A painter has only one language; as for the rest . . ." And his sentence ends with a shrug of his shoulders. (Vallentin, 1957)

"Why do you think I date everything I do? Because it is not sufficient to know an artist's works—it is also necessary to know when he did them, why, how, under what circumstances. . . . Some day there will undoubtedly be a science—it may be called the science of man—which will seek to learn more about man in general through the study of the creative man. I often think about such a science, and I want to leave to posterity a documentation that will be as complete as possible. That's why I put a date on everything I do. . . ." (Brassaï, 1966, page 100)

Technique

"I want to get to the stage where nobody can tell how a picture of mine is done. What's the point of that? Simply that I want nothing but emotion given off by it." (De Zayas, 1923)

"Technique? I don't have any, or rather, I have one but it wanders a great deal, according to the mood I'm in when I begin working. I apply it at will to express my idea. I think I have discovered many methods of expression, and still I believe there are a great many more to discover." (Del Pomar, 1932, page 125)

"I usually work on a number of canvases at a time; sometimes I even take up an old one that I've not seen for years. . . . I like to work in the afternoons, but best of all at night. You see these thick curtains shut out the daylight: artificial light suits me a great deal better; it's absolutely steady, and much more exciting." (Rothenstein, 1945)

"Plastic means? Never heard of it. In painting everything is sign. Therefore it's the thing signified that matters, and not the procedure. However, there is a great difference between the sign and the word. The word 'chair' doesn't signify anything, but a painted 'chair' is already a sign. Its interpretation goes *ad infinitum*. It's the same with slang, he who uses the word 'thing' or 'thingamajig' destroys the calcified word and gives it many new poetic meanings. You've seen at the entrance a painting by an artist whose name I will not mention. Well, it's very bad. Yet the same subject matter executed with exactly the same colors by Cézanne would be very beautiful indeed. Some create masterpieces and some nothing at all. This is unexplainable. In fact, why do two colors, put one next to the other, sing? Can one

really explain this? No. Just as one can never learn how to paint."
(Jakovsky, 1946)

Picasso told me a short while ago,* looking at one of his paintings
of 1949: "All the same, it's maybe not so bad at all what we did. . . .
In any case, there aren't any more tricks. It's the painter as he really
is. Before, there were all sorts of tricks." (Kahnweiler, 1951)

* May 17, 1951.

"It's odd," Picasso says to Pignon, "how people have a horror of technique in anything. Just imagine a matador who knows nothing at all. He would have to improvise the death in the ring. Or rather his own death, with a bull weighing thirteen hundredweight. . . . It's the same in painting. The more technique you have, the less you have to worry about it. The more technique there is, the less there is. . . . But people also make thinking too much a reproach. Very well then, no technique, no thought, but there's still the bull. Better die therefore before going into the ring, for that's what they want. As for painters, you notice they'll undertake it themselves, if the painter doesn't do it on his own." (Parmelin, 1963, pages 158–159)

The conversation turns to the freedom that a masterful technique gives the artist.

"Yes," says Picasso. "But on condition that one has so much technique that it completely ceases to exist. It disappears. At that stage, yes, it's important to have it. Because the technique does its job and you have only to busy yourself with what you're trying to find." (Parmelin, 1965, page 114)

VII

The Nude

"I want to say the nude. I don't want to do a nude as a nude. I want only to *say* breast, *say* foot, *say* hand or belly. To find the way to say it—that's enough. I don't want to *paint* the nude from head to foot, but succeed in *saying*. That's what I want. When one is talking about it, a single word is enough. For you, one look and the nude tells you what she is, without verbiage."

Picasso says to Pignon: "We must find the way to paint the nude *as she is*. We must enable the viewer to paint the nude himself with his eyes.

"You know, it's just like being a peddler. You want two breasts? Well, here you are—two breasts. . . .

"We must see to it that the man looking at the picture has at hand everything he needs to paint a nude. If you really give him everything he needs—and the best—he'll put everything where it belongs, with his own eyes. Each person will make for himself the kind of nude he wants, with the nude that I will have made for him." (Parmelin, 1965, pages 15–16

Picasso says to Pignon: "You paint washers-up and more washers-up, always washers-up. But is one single one of them a real washer-up? Just as he is? No. I paint, let's say, women or heads. Women, women, women. And yet can you say that it's Woman, just as she is? No. What I should like to do is paint Woman as she is, or your head as it is. . . . And that's what I've got to do." (Parmelin, 1969, page 114)

4.1.54.

Drawing

Picasso said to me once with a good deal of bitterness, they say I can draw better than Raphael and probably they are right, perhaps I do draw better but if I can draw as well as Raphael I have at least the right to choose my way and they should recognize it, that right, but no, they say no. (Stein, 1959, page 16)

"Some friends and I were together and we decided to draw in the dark in a manner completely automatic. The first time, I exclaimed while drawing, 'I know what I'm making—the head of a woman.' When we turned on the lights, we saw that it was in fact the head of a woman which I might have drawn in full daylight. We turned off the lights again and began again, and this time I said I was absolutely unaware of what I was making. When the lights were on again, I saw that it was exactly the same head of a woman as before, but in reverse." (Tériade, 1933, page 13)

"Look at these drawings: it's not that I intended to stylize them that they've become what they are. It's simply that the superficiality has left them. I didn't look for anything 'expressly.' . . . Evidently, there is no other key for that but poetry. . . . If the lines and forms rhyme and become animated, it's like a poem. To achieve it, it is not necessary to use many words. Sometimes there is much more poetry in two or three lines than in the longest of poems." (Jakovsky, 1946)

"Rhythm is a perception of time. The repetition of the pattern of this wicker chair is a rhythm. The fatigue of one's hand as one draws is a perception of time." (Liberman, 1956)

"I've won when that which I'm doing begins to talk without me. What I have achieved now, I believe, is that I've gone beyond the artisan stage in the art of drawing, you know, when one draws a foot and a hand and one barely succeeds to avoid finding the word 'foot' on the drawing of a foot and 'hand' on a drawing of a hand. . . . There is nothing more interesting than people. One paints and one draws to learn to see people, to see oneself. When I worked at the painting *War and Peace* and the series of these drawings, I picked up my sketchbooks daily, telling myself: 'What will I learn of myself that I didn't know?' And when it isn't me any more who is talking but the drawings I made, and when they escape and mock me, then I know I've achieved my goal." (Roy, 1956, page 122)

When visiting an exhibition of children's drawings, some years later, he remarked: "When I was their age I could draw like Raphael, but it took me a lifetime to learn to draw like them."* It was only this profound humility which could open to him the secret of instilling life into myths and symbols. (Penrose, 1958, page 275)

"A boy who draws like Raphael would be punished today; they expect of him children's drawings." (Gasser, 1958)

Madrid, 3rd November '97

My friend,

Today I am writing to you on rose-coloured paper, as might have been done by the same of gold.

What painters they are, my friend . . . they have no common sense, it happens with them just as I thought, as always; Velázquez, the painting, Michael Angelo, the sculpture, etc., etc. Sr Moreno Carbonero said to me the other night at the life class where he teaches, that the figure that I was doing was very good in proportions and drawing, but that I ought to draw with straight lines as that was better, but above all what I ought to do was to do the placing (not of lace bobbins). That is to say what one should make is a box to pack a figure in. It seems impossible that such stupidities are said. Isn't that true? But there is no doubt that however far from one's way of

* Herbert Read, letter to *The Times*, October 26, 1956.

thought, he knows, as he does not draw badly, and I must say that he is the one who draws the better, as he went to Paris and went to several academies. But don't be mistaken, here in Spain we are not stupid as we have always demonstrated, but we are educated very badly. That is why, as I told you, if I had a son who wanted to be a painter, I would not keep him in Spain a moment, and do not imagine I would send him to Paris (where I would gladly be myself) but to Munik (I do not know if it is spelt like this), as it is a city where painting is studied seriously without regard to fixed ideas of any sort, such as pointillism and all the rest, although I do not think it is bad to do it in such a way, but not just because to some authors things turn out well others should follow in his track. I am not for following a determined school as it brings out nothing but the mannerism of those who follow this way.

The Museum of paintings is beautiful. Velázquez first class; from El Greco some magnificent heads, Murillo does not convince me in every one of his pictures. Titian has a very good *Mater Dolorosa*, Vandyck some portraits and a *Capture of Christ*, 'the bid.' Rubens has his painting of the *Serpent of Fire* which is a prodigy. Teniers some small paintings of drunkards, very good: I can't remember anything more now. And everywhere some Madrid girls that no Turkish girls could surpass.

I am going to do you a drawing for you to take to the *Barcelona Comica*, to see if they will buy it, and you shall see. Modernist it must be, as the paper is. Neither Nonell nor the young mystic, or Pichot, or anybody has reached the extravagance that my drawing shall have. You shall see.

Good-by, I am sorry I did not take leave of you.

Kisses to [drawing of a hand holding a flower—a rose] from [drawing of a round object with a head; underneath, in between brackets:] an ounce.

An embrace from your friend

P. Ruiz Picasso

Till today, 20th, I have not remembered to send this letter. Give many regards to everybody and yourself receive an embrace from your friend

P.R.P.

I have news that the professor from there is a calamity.

Good-by [In the original written in Catalan].

After having closed this I have remembered that I have not told you where I live. It is Calle de S. Pedro Martir No. 5, second floor on the left. Here you have a room or a humble hut, as a snobbish lady would say.

Good-by. (Salas, 1960)

Picasso says (he is talking to a painter): "For instance, when you draw a head, you must draw a head, you must draw like that head. . . . Ingres drew like Ingres, not like the things he drew. If, for instance, you take a tree. At the foot of the tree there is a goat, and beside the goat a little girl tending the goat. Well, you need a different drawing for each. The goat is round, the little girl is square, and the tree is a tree. And yet people draw all three in the same way. That is what is false. Each should be drawn in a completely different way." (Parmelin, 1964, page 135)

EN MANIÈRE D'INTRODUCTION
PAR
PABLO PICASSO

PICASSO: "I don't know. Ideas are just simple points of departure. It's rare for me to be able to pinpoint them, just as they came to my mind. As soon as I set to work, others seem to flow from the pen. To know what you want to draw, you have to begin drawing it. If it turns out to be a man, I draw a man—if it's a woman, I draw a woman. There's an old Spanish proverb: 'If it has a beard, it's a man; if it doesn't have a beard, it's a woman.' Or, in another version: 'If it has a beard, it's Saint Joseph; if it doesn't have a beard, it's the Virgin Mary.' Wonderful proverb, isn't it? When I have a blank sheet of paper in front of me, it runs through my head all the time. Despite any will I may have in the matter, what I express interests me more than my ideas. . . ." (Brassaï, 1966, page 55)

Landscape Painting

"You have to turn in order to paint the landscape with your eyes. To see a thing you have to see all of it. Landscapes must be painted with the eyes and not with the prejudices that are in our heads. Perhaps not with the eyes closed, but with the eyes . . ." (pointing to a porcelain form on the high-tension wires in the foreground). "It would be nice to paint only detail. But in order to understand it and transform it into an image, it is necessary to paint the entire vista which makes it exist like this. It is not possible to paint it directly without all its infinite relationships. Once I painted an interminable landscape: hills, terraces, sea, trees and I don't know what all. At a certain point I found on my way a fish. I painted it with great attention, avidly. At the end I realized that all the rest wasn't the least bit important to me. I wanted to paint precisely that fish. But the fish alone I would not have known how to see." (Trombadori, 1964)

Photography

Rome, 1949

To the painter M.M., who asked him if it were still possible to paint figures after photography, cinema, etc.

PICASSO: On the contrary, it seems to me that it is only possible now. Now we know at least everything that painting isn't. (Guttuso, 1964)

PICASSO: "When you see what you express through photography, you realize all the things that can no longer be the objective of painting. Why should the artist persist in treating subjects that can be established so clearly with the lens of a camera? It would be absurd, wouldn't it? Photography has arrived at a point where it is capable of liberating painting from all literature, from the anecdote, and even from the subject. In any case, a certain aspect of the subject now belongs to the domain of photography. So shouldn't painters profit from their newly acquired liberty, and make use of it to do other things?" (Brassaï, 1966, pages 46–47)

Portraits

"When you start with a portrait and search for a pure form, a clear volume, through successive eliminations, you arrive inevitably at the egg. Likewise, starting with the egg and following the same process in reverse, one finishes with the portrait. But art, I believe, escapes these simplistic exercises which consist in going from one extreme to the other. It's necessary to know when to stop." (Tériade, 1932)

The author asks what importance Picasso gives to likeness in portraits. He answers: "None. It's not important to me to know whether a certain portrait is a good likeness or not. Years, centuries pass, and it is not important if the physiognomical traits are exactly those of the person portrayed. The artist loses himself in a futile effort if he wants to be realistic. The work can be beautiful even if it doesn't have a conventional likeness." (Del Pomar, 1932, page 129)

"I don't search for anything," said he. "I try to put as much humanity as possible into my paintings. It's too bad if this offends some conventional idolizers of the human figure. Besides, all they have to do is to look a little more attentively into a mirror. . . . What is a face, really? Its own photo? Its make-up? Or is it a face as painted by such or such painter? That which is in front? Inside? Behind? And the rest? Doesn't everyone look at himself in his own particular way? Deformations simply do not exist. Daumier and Lautrec saw a face differently from Ingres or Renoir, that's all. As for me, I see it this way. . . ." (Jakovsky, 1946)

Apollinaire, when he came to see the *Demoiselles d'Avignon*, brought with him the critic Félix Fénéon, who had a reputation for

discovering talent among the young, but the only encouragement that he could offer was to advise Picasso to devote himself to caricature. Talking of this later, Picasso remarked that this was not so stupid since all good portraits are in some degree caricatures. (Penrose, 1958, page 126)

"The head is a very odd thing. Sometimes I say to myself: I am ordering this or that, and after, I see that no, everything continues to be mixed up." (Cela, 1960)

Religious Art

"What do they mean by religious art?" I have heard him say. "It's an absurdity. How can you make religious art one day and another kind the next?" (Penrose, 1958, page 323)

Sculpture

"Statues should be put back where they really belong. Go to the Louvre, for example, drag one of those Egyptian colossi out of its somnolence, and then set it up in the heart of a crowded neighborhood. I can well visualize this king of ancient Egypt with a smiling and funereal mask placed on the bank of the Saint-Denis Canal, his majestic black silhouette standing out against the yellow sky at the hour when the workmen leave the factories, facing the iridescent waters of the canal in which the factory-smoke is reflected. The whole landscape would be changed at a single stroke. . . ."

Picasso is not a theoretician but he is passionately fond of everything connected with his craft. Does the talk turn to sculpture? He shows us a panther's skull, then a horse's skull, and points out to us that the bony corner of the eye always has the same fissure. In this connection he tells us: "The entire skeleton has been not sculpted but modeled. There is not a bone where one cannot find the trace of a thumb and which has not been completely modeled. The same thing goes for all the bones except the orbit of the eye. The edges of the orbit in the part touching the sinus have not been polished; they have been 'broken.' The mud has been kneaded around this cavity, pressed between the thumb and index finger, then let go at the precise moment when the element hardened in a fissure, unique in the skeleton; later its indentation permits the eye to be properly fixed.

"If the edges of the orbit had been smoothed and polished like the rest of the cranial case, the eye could not remain there. All the life in the work depends perhaps on this fusion of sculpture and modeling. It is at the precise moment when the creator, who holds the mud between thumb and index finger, is about to choose between the smooth perfection of the skeleton and the torn wrinkledness of the orbit, that the future life of what he has created is decided. Life is perhaps this

hesitation, this point of equilibrium. Sculpture is the art of the intelligence." (Parrot, 1948, pages 9–10)

"Primitive scultpure has never been surpassed. Have you noticed the precision of the lines engraved in the caverns? . . . You have seen reproductions. . . . The Assyrian bas-reliefs still keep a similar purity of expression."

"How do you explain to yourself," I asked, "the disappearance of this marvelous simplicity?"

"This is due to the fact that man ceased to be simple. He wanted to see fàrther and so he lost the faculty of understanding that which he had within the reach of his vision. When one reflects, one pauses. I do not mean to say that one stops along the way while walking, but that one's machinery breaks down, and once this happens it is the end. If you balance yourself at the brink of an abyss you'll fall. . . ." (Sebartés, 1948, page 213)

29 bis, rue d'Astorg
2 October 1933

Picasso tells me that, to avoid casting at Boisgeloup* he did sculptures in hollowed sand into which he then poured plaster. Result: relief sculpture in plaster.

"And," said he, "I wanted to paint these sculptures. At any rate, painting will never be anything but an imitative art. If one uses black the spectator has the feeling (thinks) that 'it turns' and, obviously, one cannot create depths otherwise. Whereas, if one paints the sculpture in pink, it will be just pink."

I: "So you're returning to your old problems. And that's why, twenty four years ago you created a piano in relief."**

PICASSO: "Yes, and the neck of a violin."

I: "Even the superimposed areas (plans) of 1913 evidently were nothing but imitations of sculpture, your sculptures at the time."

PICASSO: "That's the real reason why I wanted to make colored sculptures. Obviously, only the line drawing avoids being imitative.

* Picasso's property near Gisors.
** He attempted to incorporate in his painting a "real relief."

That's the reason why, as I told you the other day, I liked the *Metamorphoses*."*

I: "Yes, a line drawing does not imitate light whereas, obviously, painting is concerned with imitation of light."

PICASSO: "Yes, the line drawing has its own, innate light and does not imitate it." (Kahnweiler, 1952)

8 July 1948

PICASSO: "You should make ceramics. It's magnificent!" (*Turning to me:*) "The head is baked." (*Turning to Laurens:*) "I made a head. Well, one can look at it from any angle and it's *flat*. It's the paint which renders it flat, naturally—since it's painted. I saw to it that the color should make it seem flat in every sense. What is it that one looks for in a painting: depth, a maximum of space. In sculpture one must strive to achieve flatness from any point of the spectator's view. . . ."

Some time later he looks at one of his collages from 1914 and he says: "We must have been crazy, or cowards, to abandon this! We had such magnificent means. Look how beautiful this is—not because I did it, naturally—and we had these means yet I turned back to oil paint and you to marble. It's insane!" (Kahnweiler, 1956)

Notre Dame de Vie
February 2, 1964

PICASSO: Sculpture is the best comment that a painter can make on painting. (Guttuso, 1964)

PICASSO: "It seems strange to me that we ever arrived at the idea of making statues from marble. I understand how you can see something in the root of a tree, a crevice in a wall, a corroded bit of stone, or a pebble. . . But marble? It stands there like a block, suggesting no form or image. It doesn't inspire. How could Michelangelo have seen his *David* in a block of marble? If it occurred to man to create his own images, it's because he discovered them all around him, almost formed, already within his grasp. He saw them in a bone, in the

* Seven etchings for the *Metamorphoses* of Ovid, which are line drawings.

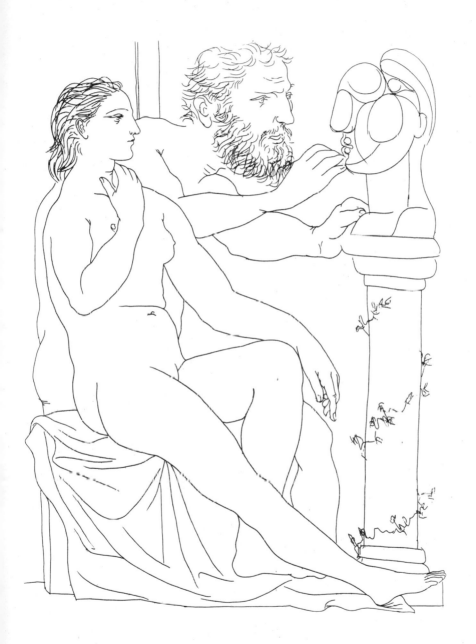

irregular surfaces of cavern walls, in a piece of wood. . . . One form might suggest a woman, another a bison, and still another the head of a demon. . . ." (Brassaï, 1966, page 70)

Talking of *Woman's Head* of 1909, Picasso told Penrose: "I thought that the curves you see on the surface should continue into the interior. I had the idea of doing them in wire." This solution, Penrose says, didn't please him because "it was too intellectual, too much like painting." (Penrose, 1967, page 19)

Penrose mentions Picasso's projects for building twenty stories or more high with balconies on their curved surfaces. Picasso said to him: "Why shouldn't you use curved surfaces for walls? I would like to make houses from inside—like a human body, not just walls with no thought of what they enclose." (Penrose, 1967, page 32)

VIII

Against Museums

"That is why the picture-book is the ruination of a painting—a painting which has always a certain significance, at least as much as the man who did it. As soon as it is bought and hung on a wall, it takes on quite a different kind of significance, and the painting is done for." (Zervos, 1935)

———

"Museums are just a lot of lies, and the people who make art their business are mostly impostors." (Zervos, 1935)

———

"One day I visited the retrospective show of the Salon. I noticed this; a good picture hung amidst bad pictures becomes a bad picture and a bad painting hung amidst good paintings manages to look good." (Tériade, 1932)

———

"In the museums, for example, there are only pictures that have failed. . . . Are you smiling? Think it over and you will see whether or not I am right. Those which today we consider 'masterpieces' are those which departed most from the rules laid down by the masters of the period. The best works are those which show most clearly the 'stigma' of the artist who painted them." (Sabartés, 1948, page 209)

Once when visiting Picasso in his apartment on the rue la Boétie I happened to notice that a large Renoir hanging over the fireplace was crooked. "It's better like that," he said. "If you want to kill a picture all you have to do is to hang it beautifully on a nail and soon you will see nothing of it but the frame. When it's out of place you see it better." (Penrose, 1958, page 71)

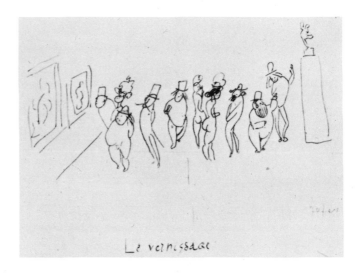

Le vernissage

Against Theories and Art Criticism

"Mathematics, trigonometry, chemistry, psychoanalysis, music and whatnot, have been related to cubism to give it an easier interpretation. All this has been pure literature, not to say nonsense, which brought bad results, blinding people with theories." (De Zayas, 1923)

———

"A friend who wrote a book on my sculptures began like this: 'Picasso told me one day that the straight line is the shortest route from one point to another.' I was astonished and asked him: 'Are you sure that it was I who discovered that?' " (Tériade, 1932)

"Art for art's sake? Why not? Utility in art? Why not? Everything depends on under what circumstances it springs up and the promptings of the epoch in which it unfolds. Critics, mathematicians, scientists and busybodies want to classify everything, marking the boundaries and limits; making one thing prevail over another, when in reality, two statements can exist at the same time. In art there is room for all possibilities. Raphael, the great master, cultivating his art as brilliantly as he did, was useful for religion without being himself religious. And I'm sure that he was only concerned with making beautiful works. Today they continue to be instructively useful and will continue to be for future generations." (Del Pomar, 1932, page 118)

"We make things for somebody. This idea of art for art's sake is a hoax." (Giménez Caballero, 1935, page 47)

"What would an art critic say if he were to see it for the first time?

"I'm not worried about what he would say. That would depend on what school he belonged to. Some critics prefer a sea bluer than this, or less green, because on looking at the sea they seek the idea which they have formed of it through a picture which they have accepted as good because they have been told that it is good or because they think that the signature of the painter is worth a lot of money." (Sabartés, 1946, pages 207–208)

When a young painter wants to explain his theories, he stops him: "But say it with brushes and paint." (Georges-Michel, 1954, page 101)

A young intellectual with steel-rimmed glasses and a mustache bores Picasso with a bunch of pedantic words, the infrastructure of art, the content and means of expression, the form and the ground. Finally Picasso can't take it any more:

"The form, the ground, the form, the ground. . . . What is the form? What is the ground? That which is the basis of the wood strawberry is the seed, and the seed is on the surface. Then, where is the basis of the strawberry, and its form?" (Roy, 1956, page 94)

"When I read a book on Einstein's physics of which I understood nothing, it doesn't matter: that will make me understand *something else*." (Roy, 1956, page 64)

I have never heard him mention the name of a pass. One evening in a café Pignon was reading an article by a bullfighting specialist which was so full of technical terms that it gave one a headache. "One day, I really must learn the names of the passes. . . ." he said. Picasso replied that he must do nothing of the kind, that it would spoil everything. And then, he went on, don't read that stuff, it's like art criticism, it's for the others, not for us. . . . (Parmelin, 1963, page 144)

Art as Legend

Later he used to say quite often, paper lasts quite as well as paint and after all if it all ages together, why not, and he said further, after all, later, no one will see the picture, they will see the legend of the picture, the legend that the picture has created, then it makes no difference if the picture lasts or does not last. Later they will restore it, a picture lives by its legend, not by anything else. (Stein, 1959, page 27)

———

When Zervos wanted to show Picasso his notes Picasso replied: "You don't need to show them to me. The essential thing in our period of weak morale is to create enthusiasm. How many people have actually read Homer? All the same the whole world talks of him. In this way the homeric legend is created. A legend in this sense provokes a valuable stimulus. Enthusiasm is what we need most, we and the younger generation." (Barr, 1946, page 272)

"After all," he said one day, "the only thing that's important is the legend created by the picture, and not whether it continues to exist itself." (Brassaï, 1966, page 40)

Culture

Another day he lashed out at the word "culture": "Don't you agree with me that they make too much fuss about that big word? It reminds me of a joke which my father used to tell: 'They say that the flu is going around. . . . Well, it must be going around pretty slowly because everybody is catching it!' With culture it is just the reverse: if

everybody is looking for it, apparently nobody is finding it. If we were cultured, we would not be conscious of lacking culture. We would regard it as something natural and would not make so much fuss about it. And if we knew the real value of this word we would be cultured enough not to give it so much importance. I feel that it is as ridiculous to want to impose 'our culture' on others as to praise fried potatoes to a guest, or to want to impose them on a neighbor, without any regard to whether or not they agree with him, or if he loathes them." (Sabartés, 1946, pages 209–210)

Importance of Place

When Albert Junyent asked Picasso in an interview at Boisgeloup if a specific place was important to him, Picasso replied: "It all depends. From a personal point of view, yes. But professionally, I believe it must be very annoying to go to the other side of the world—as Matisse did, following the route of Gauguin—in order to end up with the discovery that the quality of light, and the essential elements of the landscape which the eye of the painter perceives, are not so different, after all, from those he would find on the Marne or the Ampurdan. Indeed, look at the sky today and tell me if a more intense blue ever was seen in Málaga or Alicante—and here we are in Normandy! Ah, literature!" (Junyent, 1934)

Poetry

Picasso wrote this line:

"Le cygne sur le lac fait le scorpion à sa manière . . ."

A friend asked him what he had in mind. The artist picked up a pen and scribbled on the back of an envelope a swan floating on sleek water which reflects exactly the bird's long sickle-shaped neck. Anyone who will make the experiment for himself will perceive that he has designed the image of a scorpion in the swan's manner. (Bell, 1936, page 533)

Cannes, La Californie
7.11.1959

Picasso, after reading from a sketchbook containing poems in Spanish, says to me: "Poetry—but everything you find in these poems one can also find in my paintings. So many painters today have forgotten poetry in their paintings—and it's the most important thing: poetry." (Kahnweiler, 1959)

Grand air

La rive les mains tremblantes,
Descendait sous la pluie
Un escalier de brumes
Tu sortais toute nue
Faux-marbre palpitant
Teint de bon matin
Trésor gardé par des bêtes immenses
Qui gardaient elles du soleil sous leurs ailes,
Pour toi
Des bêtes que nous connaissions sans la voir

Par delà les murs de nos nuits
Par delà l'horizon de nos baisers
Le rire contagieux des hyènes
Pouvait bien ronger les vieux os
Des êtres qui vivent un par un

Nous jouions au soleil à la pluie à la mer
A n'avoir qu'un regard qu'un ciel et qu'une mer
Les nôtres

Paul Éluard

3.6.36
5 heures - 5 heures 15

Writing and Painting

"And then they asked me," he goes on, "why I didn't write. It's very easy to write when you're a writer; you have the words trained and they come to your hand like birds. But I will really write a book," and he says it as though wanting to convince himself that he will, "a book as thick as this, and I'll offer a prize of a dozen bottles of champagne to whoever can read more than three lines of it." (Ferran, 1926)

Picasso asked a painter during the Nazi occupation: "What are you painting now?" The painter: "I paint what I can." To which Picasso answers: "I paint what I want!" (Szittya, 1947)

"Poems?" he said to me, "there are stacks of poems sleeping here. When I began to write them I wanted to prepare myself a palette of words, as if I were dealing with colors. All these words were weighed, filtered and appraised. I don't put much stock in spontaneous expressions of the unconscious and it would be stupid to think that one can provoke them at will.

"The work of madmen," he told me, "is always based on a law that has ceased to operate. Madmen are men who have lost their imagination. Their manual memory belongs to a realm of rigid mechanism. It is an infernal machine that breaks down and not an intelligence that progresses and constantly creates in order to progress. One cannot compare poems resulting from automatic writing with those of the insane. The work of a madman is a dead work; the poetry it contains is like the ghost which refuses to give up its corpse." (Parrot, 1948, page 8)

After a swim, on the beach at Golfe-Juan, we are talking about Chinese characters (*écriture*). A Chinese friend is drawing Chinese characters in the sand. Picasso had amused himself before by drawing his own ideograms in the sand: bulls, goats, faces of peace. He is fascinated (*il se passionne*) by the interplay of Chinese characters, the strengths and economy of their construction.

"If I were born Chinese," says he, "I would not be a painter but a writer. *I'd write my pictures.*" (Roy, 1956, page 112)

"After all," he enjoys saying, "the arts are all the same; you can write a picture in words just as you can paint sensations in a poem. 'Blue'—what does 'blue' mean? There are thousands of sensations that we call 'blue.' You can speak of the blue of a packet of Gauloise and in that case you can talk of the Gauloise blue of eyes, or on the contrary, just as they do in a Paris restaurant, you can talk of a steak

being blue when you mean red. That is what I have often done when I have tried to write poems." (Penrose, 1958, pages 366–367)

"What is necessary, is to name things. They must be called by their name. I name the eye. I name the foot. I name my dog's head on someone's knees. I name the knees. . . . To name. That's all. That's enough." (Parmelin, 1964, page 45)

IX

Picasso Explains

(Interview with Jerome Seckler, 1945)

In civilian life, Pfc Jerome Seckler worked in the lumber business and is an amateur painter of talent. His first interview with Picasso took place on November 18, 1944. At the second interview, on January 6, Picasso approved Seckler's notes on the first. Picasso had no opportunity to approve the account of the second talk, but both interviews appear to be conscientiously reported, with the repetitions and false starts which characterize actual conversation. Picasso seems to have been both friendly and extraordinarily patient throughout, as if he as well as Seckler wanted to reach the precise truth. A copy of Seckler's complete manuscript is in the archives of the Museum of Modern Art. The New Masses publication is somewhat condensed. . . .

Throughout these interviews Picasso held his ground against Seckler's persistent effort to get him to admit that his paintings carried conscious political implications. Picasso admitted the possibility of unconscious symbolism and the interest and value of some symbolic interpretation by others: "embroidery on the subject—it's stimulating." But he refused to consider the idea of changing his style or subject matter to meet any possible social or political obligations. In the end, however, he agreed that there was a connection between art and politics. (Note from Barr, 1946, page 268)

For the past ten years my friends and I had discussed, analyzed and rehashed Picasso to the point of exasperation. I say exasperation because very simply it was just that. The only conclusion we could ever arrive at was that Picasso, in his various so-called "periods," quite accurately reflected the very hectic contradictions of the times, but only reflected them, never painting anything to increase one's understanding of these times. Various artists and critics who make

their living by putting labels on people identified him with a wide variety of schools—surrealist, classicist, abstractionist, exhibitionist and even contortionist. But beyond this lot of fancy nonsense, these people never did explain Picasso. He remained an enigma.

Then came the bombshell. In the midst of the last agonized hours of Loyalist Spain, Picasso painted his Guernica mural, and with this mural emerged as a powerful and penetrating painter of social protest. But there was only the *Guernica*. Up to the time France entered the war there were no echoes in Picasso's painting of the furious protest that had produced the *Guernica*. Then came France's military disaster and her humiliating occupation by the Germans. Nasty stories circulated about Picasso. That he was living well in Paris under the Germans; that he played ball with the Gestapo, which in return permitted him to paint unmolested. That he was selling the Nazi fakes— works he signed, but which were actually painted by his students. Still another that he was dead. From 1940 until the liberation of Paris, Picasso remained a figure completely surrounded by mystery and obscurity.

Then in October following the liberation came the electrifying news that Picasso had joined the Communist Party.

In that same month liberated Paris held a gigantic exhibition of contemporary French art, one room of which was especially devoted to Picasso—seventy-four paintings and five sculptures, most of them executed during the occupation. The exhibition startled me. It was the Picasso of the *Guernica*, painting powerfully, painting beautifully, painting of life and hope.

I was so excited by Picasso's work I determined to see him. Through a young French artist who knew him I managed to get his address. At his studio I was told, after a whispered conversation in another room, that Picasso was "not at home." His secretary explained, "Picasso has not painted for two months what with all that was happening, and now he wants to settle down and do some work." But finally my young artist friend arranged a meeting for me, and at 11:30 of a Saturday morning I arrived at his studio, was ushered in and told to wait.

Picasso occupies the top two floors of a definitely unpretentious place, a four-story building close to the Seine. To get up to his studio one enters one of the holes in the wall that pass for doorways and

climbs three flights up a narrow winding stairway with bare walls and worn wooden steps. This has been his home and his studio for the past eight years. You enter directly into one of the studios, a room with several easels, paintings, books—without order. As I waited I noticed one of his recent paintings on an easel, of a metal pitcher on a table. Tacked above the painting was a small pencil sketch of the composition, which the painting duplicated down to the last line and detail. Though it was only a quick sketch, he had followed it so closely that when he crossed lines at the corner of a table he also crossed them in the painting.

I asked his secretary if Picasso had had trouble with the Germans. "Like everyone," he said, "we had hard times." Picasso was not permitted to exhibit. Once the Gestapo came and accused Picasso of being in reality a man called Leipzig. Picasso simply insisted, "No, I am Picasso, that's all." The Germans did not bother him after that, but they kept a close watch on him at all times. Nevertheless, Picasso maintained a close contact with the underground resistance movement.

After about ten minutes, Picasso came down from the upstairs studio and approached me directly. He gave me a quick glance, looked me squarely in the eyes. He was dressed in a light gray business suit, a blue cotton shirt and tie, a bright yellow handkerchief in his breast pocket—small hands but solid. I introduced myself and Picasso offered me his hand immediately. He had a warm, sincere smile, and spoke without restraint, which put me at once at ease.

I explained that I had always been interested in his work, but that he had always puzzled me, and how I felt suddenly at his recent exhibition that I understood what he was trying to say. I wanted to know him personally, and to ask him if my analyses of his paintings were correct, and if they were, to write about them for America. Then I described for Picasso my interpretation of his painting *The Sailor*, which I had seen at the Liberation Salon. I said I thought it to be a self-portrait—the sailor's suit, the net, the red butterfly showing Picasso as a person seeking a solution to the problem of the times, trying to find a better world—the sailor's garb being an indication of an active participation in this effort. He listened intently and finally said, "Yes, it's me, but I did not mean it to have any political significance at all."

I asked why he painted himself as a sailor. "Because," he answered, "I always wear a sailor shirt. See?" He opened up his shirt and pulled at his underwear—it was white with blue stripes!

"But what of the red butterfly?" I asked. "Didn't you deliberately make it red because of its political significance?"

"Not particularly," he replied. "If it has any, it was in my subconscious!"

"But," I insisted, "it must have a definite meaning for you whether you say so or not. What's in your subconscious is a result of your conscious thinking. There is no escape from reality."

He looked at me for a second and said, "Yes, it's possible and normal."

Picasso then asked if I were a writer. I told him the truth—I was not a writer, had never written before. That by vocation I worked in lumber. I was a painter too, but only by avocation, because I had to make a living. Picasso laughed and said, "Yes, I understand." Then I asked if I had his consent to write an article about him.

"Yes," he said, and then added, "For which paper?"

I told him the *New Masses*. He smiled and answered, "Yes, I know it."

He looked at the open door. There were several people waiting for him. "Let's go upstairs to the studio for a moment," he said. So we climbed the stairs to the large studio where he actually does his painting. The room was neat and clean. It didn't have the dusty, helterskelter appearance of the room downstairs.

I told Picasso that many people were saying that now, with his new political affiliations, he had become a leader in culture and politics for the people, that his influence for progress could be tremendous. Picasso nodded seriously and said, "Yes, I realize it." I mentioned how we had often discussed him back in New York, especially the Guernica mural (now on loan to the Museum of Modern Art in New York). I talked about the significance of the bull, the horse, the hands with the lifelines, etc., and the origin of the symbols in Spanish mythology. Picasso kept nodding his head as I spoke. "Yes," he said, "the bull there represents brutality, the horse the people. Yes, there I used symbolism, but not in the others."

I explained my interpretation of two of his paintings at the exhibition, one of a bull, a lamp, palette and book. The bull, I said, must

represent fascism, the lamp, by its powerful glow, the palette and book all represented culture and freedom—the things we're fighting for—the painting showing the fierce struggle going on between the two.

"No," said Picasso, "the bull is not fascism, but it is brutality and darkness."

I mentioned that now we look forward to a perhaps changed and more simple and clearly understood symbolism within his very personal idiom.

"My work is not symbolic," he answered. "Only the Guernica mural is symbolic. But in the case of the mural, that is allegoric. That's the reason I've used the horse, the bull and so on. The mural is for the definite expression and solution of a problem and that is why I used symbolism.

"Some people," he continued, "call my work for a period 'surrealism.' I am not a surrealist. I have never been out of reality. I have always been in the essence of reality [literally the "real of reality"]. If someone wished to express war it might be more elegant and literary to make a bow and arrow because that is more aesthetic, but for me, if I want to express war, I'll use a machine-gun! Now is the time in this period of changes and revolution to use a revolutionary manner of painting and not to paint like before." He then stared straight into my eyes and asked, *"Vous me croirez?"* (Do you believe me?)

I told him I understood many of his paintings at the exhibition, but that quite a few I could not figure out for myself at all. I turned to a painting of a nude and a musician that had been in the October Salon, set up against the wall to my left. It was a large distorted canvas, about five by seven feet. "For instance this," I said, "I can't understand it at all."

"It's simply a nude and a musician," he replied. "I painted it for myself. When you look at a nude made by someone else, he uses the traditional manner to express the form, and for the people that represents a nude. But for me, I use a revolutionary expression. In this painting there is no abstract significance. It's simply a nude and a musician."

I asked, "Why do you paint in such a way that your expression is so difficult for people to understand?"

"I paint this way," he replied, "because it's a result of my thought. I

have worked for years to obtain this result and if I make a step backwards, [as he spoke he actually took a step back] it will be an offense to people [the French was just that, *offense*] because that is a result of my thought. I can't use an ordinary manner just to have the satisfaction of being understood. I don't want to go down to a lower level.

"You're a painter," he continued; "you understand it's quite impossible to explain why you do this or that. I express myself through painting and I can't explain through words. I can't explain why I did it that way. For me, if I sketch a little table," he grabbed a little table just alongside to illustrate, "I see every detail. I see the size, the thickness, and I translate it in my own way." He waved a hand at a big painting of a chair at the other end of the room (it had also been in the Liberation Salon), and explained, "You see how I do it.

"It's funny," he went on, "because people see in painting things you didn't put in—they make embroidery on the subject. But it doesn't matter, because if they saw that, it's stimulating—and the essence of what they saw is really in the painting."

I asked Picasso when I could see him again, and he said he would be glad to see me any time I wished. We shook hands and I left.

I found it difficult to visit Picasso again as promptly as I wished, but on a Saturday morning some weeks later I paid him a second call. Picasso received me in his bedroom, where, when I entered, I could hear him discussing political problems to be solved within the unity of the Allies with several friends. As soon as he saw me he came over, smilingly shook hands and greeted me, "*Bonjour! Ça va bein?*" Again he was so simple and sincere that I felt as though I had known him for years. He apologized for receiving me in his bedroom. "I've had to organize myself in this little room," he said, "with my dog, my papers, my drawings, my bed, because I was freezing downstairs." His hands as usual were expressively accompanying his words, like those of an orchestra conductor's. For a small room, it certainly was crammed full. The unmade bed, several bureaus, a slanting drawing table and a large gentle-eyed dog all revolved about a little coal stove, capped by a pot of water. Scattered on the bed and table were seven or eight large etchings in color which he had just finished—with bright reds, blues, and yellows laid down in mass. On the bed also were five or six newspapers, including *L'Humanité*. Resting on a bureau on the wall

was an etched zinc plate with two prints from it, of a lemon and
a stemmed wineglass, done in the same beautiful bright colors. Over
another bureau was an old photogravure of a Rubens—a man and
woman bursting with love, very richly and sensitively done. On an-
other wall was a small Corot landscape.

I brought out my report of our first interview and we went over it
together. The article being in English, I had to translate into French.
Everything was agreeable to him, but in translating what he had said
about the bull, palette and lamp painting, I must have slipped in my
French and he misunderstood me, thinking I was quoting him as
saying the bull represented fascism.

"No," he protested, "it doesn't represent fascism."

I explained what he had said was that it did not represent fascism
but that it did represent darkness and brutality. "But that's just the
point," I said. "You make a distinction between the two. But what
distinction can there be? You know and the people of the world know
the two are the same, that wherever fascism has gone there is dark-
ness and brutality, death and destruction. There is no distinction."

Picasso shook his head as I spoke. "Yes," he said, "you are right,
but I did not try consciously to show that in my painting. If you
interpret it that way then you are correct, but still it wasn't my idea to
present it that way."

"But," I insisted, "you do think about and feel deeply these things
that are affecting the world. You recognize that what is in your
subconscious is a result of your contact with life, and your thoughts
and reactions to it. It couldn't be merely accidental that you used
precisely these particular objects and presented them in a particular
way. The political significance of these things is there whether you
consciously thought of it or not."

"Yes," he answered, "what you say is very true, but I don't know
why I used those particular objects. They don't represent anything in
particular. The bull is a bull, the palette a palette and the lamp is a
lamp. That's all. But there is definitely no political connection there
for me. Darkness and brutality, yes, but not fascism."

He motioned to the color etching of the glass and the lemon.
"There," he said, "is a glass and a lemon, its shapes and colors—reds,
blues, yellows. Can you see any political significance in that?"

"Simply as objects," I said, "no."

"Well," he continued, "it's the same with the bull, the palette and lamp." He looked earnestly at me and went on, "If I were a chemist, Communist or fascist—if I obtain in my mixture a red liquid it doesn't mean that I am expressing Communist propaganda, does it? If I paint a hammer and sickle people may think it's a representation of Communism, but for me it's only a hammer and sickle. I just want to reproduce the objects for what they are and not for what they mean. If you give a meaning to certain things in my paintings it may be very true, but it was not my idea to give this meaning. What ideas and conclusions you have got I obtained too, but instinctively, unconsciously. I make a painting for the painting. I paint the objects for what they are. It's in my subconscious. When people look at it each person gets a different meaning from it, from what each sees in it. I don't think of trying to get any particular meaning across. There is no deliberate sense of propaganda in my painting."

"Except in the *Guernica*," I suggested.

"Yes," he replied, "except in the *Guernica*. In that there is a deliberate appeal to people, a deliberate sense of propaganda."

I pulled out my cigarettes and we lit up, Picasso smoking his in the ever-present cigarette holder. He took a few puffs meditatively as though waiting for me to say something, then said quietly and simply, "I am a Communist and my painting is Communist painting." He paused for a moment, then went on. "But if I were a shoemaker, Royalist or Communist or anything else, I would not necessarily hammer my shoes in a special way to show my politics."

"And yet," I said, "what a man is and thinks can be deduced from his paintings. But it is not necessary for a socially conscious painter, for instance, to show a scene of Nazi horror or destruction, of a person with blood dripping from the mouth, or a soldier shooting a rifle." I pointed to the small coal stove with the open pot of water on it and continued, "You can paint that, you can paint a mother and son, or a child, as you did, or a family eating dinner around a table—you can paint the glass and lemon. By its very objects, colors, forms it becomes a beautiful thing, the kind of beauty we want to surround our lives with, the kind of life we are fighting this war for. Being social beings we think politically whether we intend to or not."

Picasso rested his hand on my shoulder and kept nodding his head

vigorously as I spoke, saying, "Yes, yes, that's right, that's so very true."

I told him of the stir his joining the Communist Party had caused in the art world—how the critics, still labeling him "surrealist," hopefully wanted him to continue painting as he had some years before—how they quoted him as saying there was no connection between art and politics.

Picasso laughed and said, "But we know there is a connection, yes?" and added smilingly, "but I don't try myself, that's all."

I asked Picasso if my article, and I meant to include what he had just been telling me, had his approval. "Yes," he said, "go ahead with it."

At this point some of his friends drifted over and we discussed some of the trends in American and French painting. Picasso seemed unacquainted with our leading American painters. I mentioned some, including Thomas Benton, but Picasso did not know them or their work.

"That shows the distance between our two countries," said one of Picasso's friends.

"In the United States," I said, "we don't have as many artists as

France, but on the whole our artists are more vigorous, more vital, more concerned with people than the French painters. France has had the same big names in art for the past forty or more years. From what I observed in the exhibition at the *Salon d'Automne*, the younger artists were mostly introspective, concerned mainly with technique and hardly at all with living reality. French art is still concerned with the same techniques and still lifes."

"Yes," Picasso said, "but the Americans are in the stage of the general sense. In France, that is past for us and we are now at the stage of individuality."

By then someone decided it was time for lunch. I thanked Picasso and he told me again to drop around whenever I wanted, and with a warm handshake we said *au revoir*. (Seckler, 1945)

Picasso's Statement of July 1937

In May 1937, while Picasso was painting the Guernica, *he declared his feelings in a statement made available two months later at the time of the exhibition of Spanish Republican posters in New York. It had previously been rumored that he was pro-Franco. (Note from Barr, 1946, page 202)*

The Spanish struggle is the fight of reaction against the people, against freedom. My whole life as an artist has been nothing more than a continuous struggle against reaction and the death of art. How could anybody think for a moment that I could be in agreement with reaction and death? When the rebellion began, the legally elected and democratic republican government of Spain appointed me director of the Prado Museum, a post which I immediately accepted. In the panel on which I am working,* which I shall call *Guernica*, and in all my recent works of art, I clearly express my abhorrence of the military caste which has sunk Spain in an ocean of pain and death.

The ridiculous story which the fascist propagandists have circulated throughout the world has been exposed completely many times by the great number of artists and intellectuals who have visited Spain lately. All have agreed on the great respect which the Spanish people in arms have displayed for its immense artistic treasures and the zeal which it had exhibited in saving the great store of pictures, religious paintings and tapestries from fascist incendiary bombs.

Everyone is acquainted with the barbarous bombardment of the Prado Museum by rebel airplanes, and everyone also knows how the militiamen succeeded in saving the art treasures at the risk of their

* Evidently written before the mural was completed.—ELIZABETH MC-CAUSLAND.

lives. There are no doubts possible here. On the one hand, the rebels throw incendiary bombs on museums. On the other, the people place in security the objectives of these bombs, the works of art. In Salamanca, Milan Astray cries out, "Death to intelligence." In Granada, Garcia Lorca is assassinated.

In the whole world, the purest representatives of universal culture join with the Spanish people. In Valencia I investigated the state of pictures saved from the Prado, and the world should know that the Spanish people have saved Spanish art. Many of the best works will shortly come to Paris, and the whole world will see who saves cultures and who destroys it.

As to the future of Spanish art, this much I may say to my friends in America. The contribution of the people's struggle will be enormous. No one can deny the vitality and the youth which the struggle will bring to Spanish art. Something new and strong which the consciousness of this magnificent epic will sow in the souls of Spanish artists will undoubtedly appear in their works. This contribution of the purest human values to a renascent art will be one of the greatest conquests of the Spanish people. (Barr, 1946, page 264)

Message to Artists' Congress

Picasso, Spanish artist, was to have addressed the meeting (of the American Artists' Congress) by telephone from Switzerland. . . . Because of sudden illness the artist could not telephone the message direct to Carnegie Hall as planned, and . . . late yesterday afternoon his message was relayed by telephone from Switzerland. It said:

"I am sorry I cannot speak to the American Artists' Congress in person, as was my wish, so that I might assure the artists of America, as director of the Prado Museum, that the democratic government of the Spanish Republic has taken all the necessary measures to protect the artistic treasures of Spain during this cruel and unjust war. While the Rebel planes have dropped incendiary bombs on our museums, the people and the militia, at the risk of their lives, have rescued the works of art and placed them in security.

"It is my wish at this time to remind you that I have always believed, and still believe, that artists who live and work with spiritual values cannot and should not remain indifferent to a conflict in which the highest values of humanity and civilization are at stake." (*The New York Times, 1937*)

Open Letter to a Young Spanish Artist, May 1952

I have received your letter: I know, through it, of the difficulties that encumber your path at the beginning of your artistic life, and at the same time, of the will to continue your work, hoping for a better future. Such conditions and your way of thinking undoubtedly reflect the situation of the new intellectual generation of our country—rebellious in spirit and faithful to the ideals of those men who took up arms to fight for the republic from 1936 to 1939.

For you, young painter, as for the writers and musicians of Franco Spain, the material difficulties and the absence of freedom to express all that the vivid reality of our people suggests are also obstacles to your work of artistic creation.

Such obstacles, however, no matter how great, cannot arrest our work. Spain has need of our voice: to denounce poverty and the corruption of the regime; to penetrate the heart of the people to express their feelings and incite them to struggle and to celebrate their heroism.

The problems that present themselves before the young intellectual are also familiar to the young worker who is dying of hunger without being able to find work and to the young peasant who toils from dawn to dusk for a miserable piece of bread.

The obstacle which paralyzes so much energy has a concrete name: Franco. To put an end to all this misery it is necessary to put an end to the present government. The people of Barcelona have shown the way.

This regime cannot save itself, not even with North American help. Our people will be victorious. We are millions of men and women who defend the cause of peace in the world. The dove, even today, is stronger than the raven of war.

Your place, young painter, is at the side of the people who defend freedom, and, at the same time, the artistic and cultural patrimony of Spain. There is no cause for the new intellectual generation that could be more noble than that of contributing to the salvation of Spain from fascism and war. (De Micheli, 1964, pages 50–51)

Politics

"As far as I'm concerned, I'll continue to be aesthetic, or, if you prefer, purely cerebral. I'll continue making art without preoccupying myself with the question of its influence, or if it 'humanizes' our life, as you put it. If it contains a truth, my work will be useful without my express wish. If it doesn't hold a truth, so much the worse. I will have lost my time. But I will never make art with the preconceived idea of serving the interests of the political, religious or military art of a country. I will never fit in with the followers of the prophets of Nietzsche's superman." (Del Pomar, 1932, page 131)

He believes that outside events caused him to seek a greater objectivity. He said that the tendency in the creative artist is to stabilize mankind on the verge of chaos. These are the sort of things we talked about, not using many words, but referring from time to time to the collection of pictures not yet enjoyed by the critics of the free world. There was a series of brilliantly coloured and comparatively objective paintings of the Seine round the Île St. Louis—nearly the most hackneyed landscape in Paris. There were four very exact likenesses of a boy drawn during this summer of war. There were a number of drawings of the pot of growing tomatoes which stood in the window, and at least two finished paintings clung round those same tomatoes as a central theme. "A more disciplined art, less unconstrained freedom, in a time like this is the artist's defense and guard," Picasso said. "Very likely for the poet it is a time to write sonnets. Most certainly it is not a time for the creative man to fail, to shrink, to stop working. Think of the great poets and painters of the Middle Ages." (Pudney, 1944)

"Is that story that's going around true? That one day a Gestapo officer brandished a reproduction of your *Guernica* and asked you 'Did you do that?' And you answered, 'No, you.' "

"Yes," said Picasso, smiling, "it's true, or almost. Occasionally there were Germans who came with the pretext of admiring my paintings. I used to distribute reproductions of my *Guernica* and say to them: 'Take it, souvenir, souvenir!' "

"Certain American journalists suggested that your joining the Communist Party was one of your usual whims and that you explained that art and politics had nothing in common. . . ."

"But I never said that! That's scandalous."

"But," a young American then asked maliciously, "do the Communists understand your painting?"

"There are those that do and those that don't. There are some who understand English and some who don't. There are those who understand Einstein and those who don't. Wait a minute (this is a very important question) I'm going to give you a written declaration so that no one will have any doubts in the matter."

A few minutes later Picasso excitedly returned with two pieces of notebook paper on which he had written in pencil. I deciphered with some difficulty the following aggressive sentences in the purest Picasso style:

"What do you think an artist is? An imbecile who only has eyes if he's a painter, ears if he's a musician, or a lyre in every chamber of his heart if he's a poet, or even, if he's a boxer, only some muscles? Quite the contrary, he is at the same time a political being constantly alert to the horrifying, passionate or pleasing events in the world, shaping himself completely in their image. How is it possible to be uninterested in other men and by virtue of what cold nonchalance can you detach yourself from a life that they supply so copiously? No, painting is not made to decorate apartments. It's an offensive and defensive weapon against the enemy." (Téry, 1945)

"If everyone would paint, political re-education would not be necessary." (Spender, 1946)

"We artists are indestructible; even in a prison, or in a concentration camp, I would be almighty in my own world of art, even if I had

to paint my pictures with my wet tongue on the dusty floor of my cell." (*Der Monat*, 1949)

Picasso is right in saying that a government which would punish a painter for choosing the wrong color or the wrong line would be an impressive government. (Cocteau, 1956, page 82)

Paris, 31 March 1952

The Sunday evening papers give the tragic details of the execution of Beloyannis, which took place that morning in Athens. The night, the condemned, illuminated by the gleam of wagon headlights, Beloyannis straight and scornful, the wagons which carry away the corpses, the blood dripping behind, while the cadavers bounce on the floor of the wagon, along the road full of muddy holes . . .

During the past fifteen days Picasso had multiplied his efforts on behalf of Beloyannis. Arriving that evening at the rue Gay-Lussac I found him distressed, upset and aged. He said: "It's as horrible as in the picture by Goya. . . ."

We're trying to compose a short text in which he could express his horror. I'm putting down simple phrases, suggesting a word. . . . Picasso is silent, overcome by his suffering. Suddenly he takes the piece of paper on which we in vain had tried to capture his anger and he leaves to go down to his studio. Half an hour goes by. Picasso reappears and hands me a short text—a cry: "The gleam of the oil-lanterns illuminating the May night of Madrid, the noble faces of the people being shot by the rapacious foreigner in the painting by Goya, has the same grain of horror sown in handfuls by the headlights on the open chest of Greece, by governments sweating fear and hate. An immense white dove sprinkles the wrath of its mourning over the earth." (Roy, 1956, pages 97–98)

"Do you know," he has often said to us, "of many painters who have been burnt for their opinions? . . . Burnt at the stake? . . . Both in the true and figurative senses? . . . Did many painters go into exile when Voltaire went to Prussia? . . . How many have published engravings in Holland, or exhibited subversive canvases in Switzerland or Russia? . . .

"There are many writers," he said, "who let the Commune, for instance, take place in front of their eyes, like a film in Technicolor, and even stayed where they were without moving when the performance was over. But what about the painters? There was Courbet, of course, and the Vendôme column, but it was not a canvas, it was a column. . . . True, he made drawings. But few. And they are far from the best things he did.

"Why," he asked, "can one count painters who are insurrectionary in their work on the fingers of one hand, and not writers? . . .

"Is it due to their trade? Were Van Gogh and Cézanne really less audacious in mind than Victor Hugo? . . ." (Parmelin, 1963, page 190)

Le terrible est dans les arts un don naturel comme celui de la grâce. L'artiste qui n'est pas né pour exprimer cette sensation et qui veut le tenter, est encore plus ridicule que celui qui veut se faire léger malgré sa nature.

.

Ce qui caractérise vraiment le grand poète, le grand peintre, tout grand artiste enfin, ce n'est pas seulement l'invention d'un type frappant d'une pensée, c'est sa réalisation, sa personnification par le côté plus énergique. C'est cette puissance d'imagination qui concentre en une conception tous les caractères, qui la fait exister réellement et prendre rang comme une créature complète.

DELACROIX.

Savoir pour pouvoir, telle fut ma pensée. Être à même de traduire les mœurs, les idées, l'aspect de mon époque, selon mon appréciation, être non seulement un peintre, mais encore un homme, en un mot, faire de l'art vivant, tel est mon but.

.

J'ai traversé la tradition, comme un bon nageur passerait une rivière : les académiciens s'y sont tous noyés.

COURBET.

... Ces messieurs se trouvèrent face à face avec le tableau de M. Courbet, un *Enterrement à Ornans*. Pas n'est besoin de dire l'expression d'antipathique dédain qui, à cette vue, vint se traduire sur le visage de M. Horace Vernet.

« Vous appelez cela de la peinture ? dit-il, du naturalisme ? mais dant la nature, il y a du soleil, apparemment, et je n'en vois pas la moindre trace ici. Cette scène ne se passe pas sons le ciel... Moi, quand je veux peindre, j'ouvre ma fenêtre et je peins ce que je vois. »

« Moi, répliqua M. Théodore Rousseau qui se trouvait auprès de M. Horace Vernet, quand je veux peindre, ce n'est pas ma fenêtre, c'est mon intelligence que j'ouvre. »

J.-J. ARNOUX,
Salon de 1850-51.

X

Comments on His Own Works

LES DEMOISELLES D'AVIGNON (1907)

29 bis, rue d'Astorg
2 December 1933

PICASSO: *"Les Demoiselles d'Avignon,* how this title irritates me. Salmon invented it. You know very well that the original title from the beginning had been *The Brothel of Avignon.* But do you know why? Because Avignon has always been a name I knew very well and is a part of my life. I lived not two steps away from the Calle d'Avignon where I used to buy my paper and my watercolors and also, as you know, the grandmother of Max came originally from Avignon. We used to make a lot of fun of this painting; one of the women in it was Max's grandmother, another one Fernande, and another one Marie Laurencin, and all of them in a brothel in Avignon.

"According to my original idea, there were supposed to be men in it, by the way, you've seen the drawings. There was a student holding a skull. A seaman also. The women were eating, hence the basket of fruits which I left in the painting. Then, I changed it, and it became what it is now."

A few days earlier Picasso told me that this painting was begun in 1907 and not in 1906 because, as he said, he'd started it in spring. He confirmed that there had been two periods of work on this painting. I saw the painting in its actual state in the rue Ravignan, which means after the second period and rather early in the spring of 1907. Since Picasso talks about spring, he remembers something specific and therefore cannot be mistaken. The second period of work must be placed shortly after the first and the second period marks, properly speaking, the *birth of Cubism* and must be placed in April or May of 1907. (Kahnweiler, 1952, page 24)

"It has been said that *Les Demoiselles d'Avignon* was the first picture to bear the mark of cubism; it is true. You will recall the affair in which I was involved when Apollinaire stole some statuettes from the Louvre? They were Iberian statuettes. . . . Well, if you look at the ears of *Les Demoiselles d'Avignon*, you will recognize the ears of those pieces of sculpture!

"Furthermore, it is the realization alone that counts. From this point of view it is true that cubism is Spanish in origin and that it was I who invented cubism. We should look for Spanish influence in Cézanne. He was well on the way; observe El Greco's influence on him, a Venetian painter. But he is cubist in his construction.

"But all this is a matter of outer garb and you cannot invent something you don't know! . . . Did not the men of the Renaissance fasten onto the Greeks? Why? For a *point d'appui*; so as not to be alone; because every new thing seems barbarous to the public.

"Then we cast round for justification; we looked for ancestors to give us a standing. The Nice Carnival finds its support in classical antiquity or in Venice. The fact is that we began buying Negro masks after *Les Demoiselles d'Avignon*.

"When I went along to the Trocadéro, there was no one there, just an old custodian. It was very cold; there was no fire. Everything was verminous and moth-eaten; the walls were covered with turkey twill. It was there that I found my defense. I thought it was wonderful. That's how it always happens.

"When they said that the impressionist imitated the Japanese, it means that the Japanese went bail for them. You are attacked and you defend yourself by showing that the same thing has been done before and then it is justified. But in point of fact *each* thing is original. . . ." (Souchère, 1960, pages 14–15)

THE ARCHITECT'S TABLE (1912)

Speaking of the transformations of motifs in this picture Picasso observed that he possibly could not have surely identified the point of departure in reality for all its shapes even at the time it was painted— and certainly cannot now. "All its forms can't be rationalized," he

told the author. "At the time, everyone talked about how much reality there was in Cubism. But they didn't really understand. It's not a reality you can take in your hand. It's more like a perfume—in front of you, behind you, to the sides. The scent is everywhere, but you don't quite know where it comes from." (Rubin, 1972, page 72)

GUERNICA (1937)

I remember having heard from his own lips as an *obiter dictum* that in the pictures from a certain period of his artistic development, the horse generally represents a woman who played an exceptionally important part in his life. (Larrea, 1947)

Juan Larrea's study of *Guernica* is now published in book form in English. In the course of this long essay, Mr. Larrea made the following statement: "The horse represents Spanish nationalism, the bull appears to be the symbol representing the people." (*Laughter.*)

On May 29, I received a letter from Mr. Kahnweiler:

"Dear Mr. Barr: Your letter of May 21st arrived a few days ago. Today I saw Picasso and read your letter to him. What he answered is this: I give you his own words in French."

I translate: "But this bull is a bull and this horse is a horse." (*Laughter.*) "There's a sort of bird, too, a chicken or a pigeon, I don't remember now exactly what it is, on a table. And this chicken is a chicken. Sure, they're symbols. But it isn't up to the painter to create the symbols; otherwise, it would be better if he wrote them out in so many words instead of painting them. The public who look at the picture must see in the horse and the bull symbols which they interpret as they understand them. There are some animals. That's all, so far as I'm concerned. It's up to the public to see what it wants to see."

Mr. Kahnweiler adds, "That is exactly what he said." (*Laughter.*) (Barr, 1947)

STILL LIFE WITH A BULL'S HEAD (1938)

"I painted this with four-letter words," he said as he showed me a large canvas now known as *Still Life with a Bull's Head*, in which the burning reds and yellows, a double reflection of the sun in the open window, and the monumental immobility of a horned head in the foreground, produce a shock like a deadly explosion within the calm of a distant blue sky. (Penrose, 1958, page 381)

BULL'S HEAD (TÊTE DE TAUREAU) (1943)

"Have you often made these kinds of discoveries?"

"Sometimes. You remember the head of a bull I exhibited recently? Here's how it was conceived: I noticed in a corner the seat and handlebars of a bicycle, placed in such a way that they resembled a bull's head. I assembled these two objects in a certain way.

"Finally, I made this handlebar and seat a bull's head that everyone recognized as a bull's head. The metamorphosis was accomplished and I wish another metamorphosis would occur in the reverse sense. If my bull's head were thrown in a junk heap, perhaps one day some boy would say: 'Here's something which would make a good handlebar for my bicycle. . . .' Thus, a double meatmorphosis would have been accomplished." (Warnod, 1945)

Michael Leiris had congratulated him on transforming a bicycle seat into a bull's head. Picasso said: "That's not enough. One should be able to take a piece of wood and it should be a bird." (Kahnweiler, 1946, page 262n.)

Picasso speaks of the famous bicycle seat and handlebars he combined to make a bull's head.

He says: "One day I took the seat and the handlebars. I put one on top of the other and I made a bull's head. Well and good. But what I should have done was to throw away the bull's head. Throw it in the

street, in the stream, anyway, but throw it away. Then a worker would have passed by. He'd have picked it up. And he'd have found that, perhaps, he could make a bicycle seat and handlebars with that bull's head. And he'd have done it. . . . That would have been magnificent. That's the gift of metamorphosis." (Parmelin, 1965, page 72)

"Guess how I made that head of a bull. One day, in a rubbish heap, I found an old bicycle seat, lying beside a rusted handlebar . . . and my mind instantly linked them together. The idea for this *Tête de Taureau* came to me before I had even realized it. I just soldered them together. The thing that's marvelous about bronze is that it can give the most diverse objects such unity that sometimes it's difficult to identify the elements that make up the whole. But that's also a danger: if you no longer see anything but the head of a bull, and not the bicycle seat and handlebar that formed it, the sculpture would lose its interest." (Brassaï, 1966, page 52)

WAR AND PEACE (1952)

It's extremely rare that Picasso doesn't know where he is going, that the picture paints itself, that he doesn't direct the operation. But, to a certain extent, this is the case with the painting *War and Peace*. He let himself be directed by the painted dialogue extending itself over these one hundred square meters.

"None of my paintings has been painted with more speed as far as the covered surface," he told me yesterday. "I filled entire sketchbooks with sketches, details, but I had no outline of the total picture. I began with the *War* part. What imposed itself first in my mind was the awkward and jolting course of one of those provincial hearses that one sees passing in the streets of little towns, so pitiful and screeching. I began to paint from the right side, and it's around this image that the rest of the painting was constructed. I could not push every part separately as I used to with my paintings which were partly based on analogous themes, for example, as in the series of the knights of the Middle Ages, where I developed variations on the figure of the battle

steed (charger), caparisoned and harnessed. In modern painting, every touch becomes an act of precision and is part of a clockwork. You paint the beard of a personage and the beard is red and this red leads you to readjust everything around it and to place it in relation to the totality, to repaint everything like a chain reaction. I wanted to avoid this, I wanted to paint as one writes, to paint as quickly and fast as the thought happens, within the rhythm of the imagination. There were months, years even, when I felt like everyone else, obsessed by the menace of war, filled with anxiety and hatred, and the wish to fight this anxiety and hatred. The *Massacres in Korea* was already conceived as a result of all this. This picture disconcerted and displeased. But I begin to see it now for what it is and I know now why it had been received with surprise: I hadn't painted another *Guernica* —and that's what I was expected to do." (Roy, 1956, pages 110–111)

Picasso, speaking ironically about the difficulties raised by the authorities at the inauguration of his two panels of *War and Peace* in the chapel at Vallauris: "I don't make speeches. I speak through painting. That's why they wanted to impede the opening of the temple of peace today. The wars conducted against the people are always laden with fascism. That's the way it happened with Franco in '36. It reminds me of the time Spain had lost Flanders and the Low Countries and all its empire: a painter of blazons executed for the king a heraldic emblem with a well with a bucket and crank. The legend declared: The more you take away, the more there is.

"To call up the face of war I have never thought of any particular trait, only that of monstrosity. Still less of the helmet or uniform of the American or any other army. I have nothing against the Americans. I am on the side of men, of all men. Because of that I could not imagine the face of war separated from that of peace. Even peace came to my mind only with the attributes of the absolute needs of humanity and the full liberty of everyone on earth. Art must put forward an alternative. I would like my work to help men to choose, after having obliged them to recognize themselves according to their authentic calling, among my images. So much the worse for them who are constrained to recognize themselves in pictures of war—it's still weaker not to be able to switch routes." (Trombadori, 1964)

Minotaur

"If all the ways I have been along were marked on a map and joined up with a line, it might represent a minotaur." (Souchère, 1960, page 54)

XI

Comments on Other Artists

BONNARD

"Bonnard," said Picasso, "I like him best when he isn't thinking of being a painter, when he painted pictures full of anecdotes, literature, 'told stories.' Sure, when he put down a blue, then a mauve and so a pink, that was painting. But do you know the picture of a man with a boating hat and people in a garden, and a dog? . . . I believe that it depicts the family of Tristan Bernard—what a marvelous painting! Actually, that's the best part, pictures full of literature, rotten with anecdotes, that tell stories. . . ." (Roy, 1956, page 112)

CÉZANNE

"One doesn't pay enough attention," he said to me. "If Cézanne is Cézanne, it's precisely because of that: when he is before a tree he looks attentively at what he has before his eyes; he looks at it fixedly, like a hunter lining up the animal he wants to kill. If he has a leaf, he doesn't let go. Having the leaf, he has the branch. And the tree won't escape him. Even if he only had the leaf it is already something. A picture is often nothing but that. . . . One must give it all one's attention. . . . Ah, if only everyone were capable of it!" (Sabartés, 1954, page 72)

"For us, Cézanne was like a mother who protects her children." (Kahnweiler, 1961)

"He had no gift, no skill at all for imitation. Every time he tried to copy other artists, it was a Cézanne he painted. You can wrap up your 'family Cézanne.' . . ."

Even after the young man has left, Picasso is still grumbling: "As if I didn't know Cézanne! He was my one and only master! Don't you think I looked at his pictures? I spent years studying them. . . . Cézanne! It was the same with all of us—he was like our father. It was he who protected us. . . ." (Brassaï, 1966, page 79)

GRIS

PICASSO: "Certainly, Gris only wanted to make a Chardin, and since he was honest, he didn't want to imitate him but applied his intelligence to reinvent a way to make Chardins. And, by the way, he would have achieved it if he'd lived." (Kahnweiler, 1956, page 74)

"You know quite well that Gris never painted any big pictures. I have often told you that if he had been able to develop his work a bit further, if he hadn't died so young, he would have ended up with a much more natural approach. The things in his work which are cock-eyed would have straightened themselves out."

When I protested against this last allegation, he went on. "I mean that people would have *seen* them straight."

Here I agree, for it struck me that Gris, for reasons connected with the architecture of his pictures, would not have been able to put them straight, but he would have arrived at a composition that was so convincing that people would indeed have experienced no misgivings.

"Gris knew," Picasso went on, "that he would have needed a thousand years, a thousand lives, to paint a big picture in the way he would have liked. To paint these trees (pointing to the trees in the Avenue de Messine) with all their leaves, one would have to put the whole of the Chinese population to work for a thousand years. It is essential to realize that the world we see is nothing." (Kahnweiler, 1957)

MATISSE

Bringing them out one after another, he showed me the rich variety of style and fantasy to which the *Women of Algiers* had been subjected. My first sight of the Moorish interiors and the provocative poses of the nude girls reminded me of the odalisques of Matisse.

"You are right," he said with a laugh, "when Matisse died he left his odalisques to me as a legacy, and this is my idea of the Orient, though I have never been there." (Penrose, 1958, page 351)

Picasso also enjoys discussing Matisse. One evening at Vauvern-argues, his seventeenth-century castle near Aix-en-Provence, he was showing me his Matisses—pre-*fauve* landscapes done in Switzerland, a marvelous still life of 1909 and one or two later works—when we came to the highly simplified portrait of Matisse's daughter, Marguerite, done in 1907. Picasso picked out this painting when the two artists exchanged pictures in 1908, not long after their first meeting.

"At the time people thought I had deliberately chosen a bad example of Matisse's work out of malice," Picasso said. "This is quite untrue. I thought it a key picture then, and still do. Critics are always talking about this and that influence on Matisse's work. Well, the influence on Matisse when he painted this work was his children, who had just started to draw. Their naïve drawings fascinated him and completely changed his style. Nobody realizes this, and yet it's one of the keys to Matisse." (Richardson, 1962)

PICASSO: "Matisse makes a drawing, then he makes a copy of it. He recopies it five times, ten times, always clarifying the line. He's convinced that the last, the most stripped down, is the best, the purest, the definitive one; and in fact, most of the time, it was the first. In drawing, nothing is better than the first attempt." (Brassaï, 1966, page 56)

ROUSSEAU

"Rousseau . . . represents perfection in a certain category of thought. The first work of the *douanier* which I chanced to purchase obsessed me from the moment I saw it. I was walking along the rue des Martyrs. A second-hand dealer had piles of canvases arranged along the whole storefront. A head stuck out, a woman's face with a hard look, [a work] of French insight, of decision and clearness. The

canvas was immense. I asked the price of it. 'Five francs,' said the shopkeeper, 'you can paint over it.'

"It is one of the most revealing French psychological portraits." (Fels, 1925, page 144)

ARTISTS OF THE PAST

"Velázquez left us his idea of the people of his epoch. Undoubtedly they were different from what he painted them, but we cannot conceive a Philip IV in any other way than the one Velázquez painted. Rubens also made a portrait of the same king and in Rubens' portrait he seems to be quite another person. We believe in the one painted by Velázquez, for he convinces us by his right of might." (De Zayas, 1923)

"Raphael is a great master. Velázquez is a great master. El Greco is a great master, but the secret of plastic beauty is located at a greater distance: in the Greeks at the time of Pericles." (Del Pomar, 1932, page 109)

23, rue La Boétie
6 February 1934

PICASSO: "Imagine me painting a portrait of Rembrandt. It's the old story of the cracking varnish. I had a plate where this accident happened. I said to myself: it's ruined so I'll just make do no matter what. I began to scratch on it. It became Rembrandt. This began to amuse me and I continued with it. I even followed it up with another one, complete with his turban, his fur coats, and his eye, that elephant eye of his, you know. I am now working on this plate to achieve the same blacks as he did: that's something that cannot be done at the first go."

Apropos of *La Fête du Vin*, a picture then hanging in my office, Picasso talked about the Le Nains and their clumsy simplicity: "The Le Nains—they're peasants. Look at the raised foot of this peasant. Compare it with the Zurbaráns in the Grenoble museum. And yet Zurbaráns wasn't particularly skillful. With the Le Nains, the awkwardnesses are almost proofs of authenticity. Take the belly of my horse, for example" (referring to a Le Nain picture in his possession). We looked at a photograph of this picture and indeed the belly of the horse is incredibly, impossibly, thin.

PICASSO: "Those people had plenty of ideas of composition, but they never followed them right through to the end, they lost sight of them on the way. In fact it's perhaps this awkwardness which gives them their charm. And then it's very French. Look at any of the French painters and you find the same thing. Even with the greatest, Poussin, although he taught the Italians some lessons and went further and

higher than the Italians, you find awkwardnesses. Not with the Spaniards, nor the Italians of course; with the Italians the slickness is revolting. Basically the French are all peasants."

May 14, 1935

"I'd give the whole of Italian painting for Vermeer of Delft. There's a painter who simply said what he had to say without bothering about anything else. None of those mementos of antiquity for him."

December 10, 1936

KAHNWEILER: "I've been to the Rubens Exhibition. Well, I was wrong in thinking, when I looked at the photographs, that I would like it. You were quite right; I didn't like it at all."

PICASSO: "Of course, I told you so. He's gifted, but what is the use of gifts that are merely used to produce bad stuff? Nothing is *described* in Rubens. It's simply journalism or historical films. Look at Poussin, when he paints Orpheus, well, it's described. Everything, even the tiniest leaf, tells the story. Whereas with Rubens . . . It's not even painted. Everything is the same. He thinks he can paint a large breast by doing this (describing a circle in the air) but it isn't a breast. Draperies are like breasts with him, everything's the same."

November 5, 1944

PICASSO: "People are always talking about the Renaissance—but it's really pathetic. I've been seeing some Tintorettos recently. It's nothing but cinema, cheap cinema. It makes an impression because there's plenty of people, plenty of movement and grandiloquent gestures. And then it's all about Jesus and his Apostles. But how bad it is, how vulgar, without any real understanding. The heads themselves are bad." (Kahnweiler, 1952)

Gertrude Stein says that if you are way ahead with your head you are naturally old fashioned and regular in your daily life. And Picasso

adds, do you suppose Michelangelo would have been grateful for a gift of a piece of renaissance furniture, no he wanted a Greek coin. (Stein, 1933, page 246)

Rome, Vatican, 1949

PICASSO (*in front of Raphael's frescoes*): "Good, very good. But it can be done, don't you think?" (*Before the* Last Judgment *of Michelangelo*): "What an idea, this huge blue and brown! That is more difficult." (Guttuso, 1964)

"'Yes. But a master should be free by instinct and be able to break the chain of rules even at the peril of his life. Michelangelo," Picasso continued, "I love to get lost in his work as in a rich and powerful mountain."

He was shown a photograph of one of the genies of the chapel.

"Ah!" he exclaimed, putting his finger on the toe of the Ephebe and tracing the outline, "what a pleasure it is to follow this line . . . but Raphael is sheer heaven (*le plein ciel*): what serenity these lines possess, what power. It's not Vinci, the inventor of aviation, it's Raphael! . . ."

And facing the Saint John by Vinci:

"Yes, da Vinci promises heaven: look at this raised finger. . . . But Raphael, he gives it to us." (Georges-Michel, 1954, page 95)

Rue des Grands-Augustins
14-1-55

Piscasso makes me climb to the attic with his nephew Fin once more, to look at his paintings after the *Women of Algiers* by Delacroix, on which he was working.

PICASSO: "I wonder what Delacroix would say if he saw these paintings."

I answer him that I think he would probably understand.

PICASSO: "Yes, I think so. I'll tell him: You, you, thought of Rubens and you made Delacroix. And I, thinking of you, I'm making something else."

I don't know how it happened that we started talking about Greco.

PICASSO: "What I really like about him are his portraits, these gentlemen with their pointed beards. The pictures of saints—the Trinity, the Virgin, that's Italy, it's decoration. Whereas the portraits! And that is also the reason why I prefer the Germans to the Italians. They, at least, were realists. This painter, you gave me a book of his work . . ."

I: "Altdorfer. Yes, you made a whole series of copies—drawings, magnificent drawings after him."

PICASSO: "Yes, Altdorfer. The beauty of it! That is realism. Whereas the Italians are decorative, even the greatest ones. And they always think of antiquity."

I: "And Caravaggio, your enemy? Isn't he a realist?"

PICASSO: "It's pure mockery of realism. It's a lie. It's a stage setting. The same as Feyder is in films. Put me a spotlight to the right and another on the left."

I: "However, think of his way of interpreting sacred themes. For example, Saint Matthew at the inn."

PICASSO: "But no! He's looking at the daughter of his concierge and decides to make a portrait of her and the result is Bacchus! Look at Rembrandt! He intends to paint Bathsheba, but the posing servant interests him much more—and it's her portrait he paints." (Kahnweiler, 1955, *Aujourd'hui*)

In the fall of 1953, spending a day with Picasso, I had brought a book by Benesch on Altdorfer with me. Picasso, curious about everything dealing with art, asks me to show the book to him. He becomes very excited and I present the book to him. Here follows the conversation which ensued and which I wrote down a few days later: "18.11.53. 29 bis rue d'Astorg, 5 p.m.—Picasso came to sign some lithos. We started talking. Beaudin arrives. He asks Picasso if he has worked. He answers no, he hadn't. I tell him:

'But the lithos!'

'I've made some Altdorfers,' says he. 'I copied things. . . . How good he is, Altdorfer! Everything is there: a little leaf on the ground, a broken brick, not like the others! There is a painting by him with a kind of a small closed balcony. All the details are integrated. It's beautiful. All that is lost, later on. We went all the way to Matisse—color! It may be progress but it's something else. One should copy

these things, as in the past. But I know very well it wouldn't be understood.' " (Kahnweiler, 1955, *L'Oeil*)

February 12, 1935

PICASSO: "Velázquez—when all's said and done he's even better than the Le Nains. *Las Meninas*, what a picture! What realism! There you have the true painter of reality. Of course, his other pictures are more or less good, but that one—what a marvelous achievement!"

June 22, 1946

Looking at a still-life sculpture at the Lipchitz Exhibition, Picasso said: "All the same, it was much better when he painted a guitar instead of a woman. Because that means all sorts of things. Of course you know why we began with musical instruments. After all, the rest is 'charm.' Lots of things I've done since have been nothing but charm. Whereas then . . . It's like those enormous pictures with figures that Raphael and the other Italians used to do. How could they have resisted putting a head in a corner where there was a gap?

"Look at Michelangelo's *Last Judgment*. Is it truly worked out? Is it worked out right down to the nostrils of Christ's nose? Of course not! It's just charm, decoration. When you reduce all that to its basic elements, there's enough left to make a nice tie. To produce a big picture like that would need the help of every painter since the beginning of time and even so it wouldn't be finished yet. It's like a novel. Has there ever been a man who really told the story of his life—his birth and then the whole of his life—everything, really everything? No!"

November 3, 1933

Picasso, after a visit to the Louvre, praises Rome to the detriment of Greece: "With the Greeks there's always an aesthetic element. I prefer the virile realism of Rome, which doesn't embellish. The truthfulness of Roman art—it's like their buildings, utilitarian but all the more beautiful in their genuine simplicity." (Kahnweiler, 1957)

Documentation

Bibliography

The most comprehensive Picasso bibliography is Juan Antonio Gaya Nuño's *Bibliografía Crítica y Antológica de Picasso*, published by Ediciones de la Torre, University of Puerto Rico, San Juan, 1966. I have used this bibliography extensively, along with Alfred H. Barr's early and excellent bibliography in *Picasso, Fifty Years of His Art* (New York: The Museum of Modern Art, 1946). The following is not a standard bibliography but simply a listing of the sources for material selected for this book, an expansion of the notes following each selection in the text, prepared by Bernard Karpel.

—Dore Ashton

These numbered references are restricted to those related to extracts in the preceding anthology in order to identify the sources. However, additional information concerning variant editions and sources has been added since it may suggest helpful alternates to different readers and in other libraries.

Bernard Karpel, Chief Librarian,
The Museum of Modern Art

BARR, ALFRED H., JR., 1946
1. Barr, Alfred H., Jr. *Picasso, Fifty Years of His Art.* New York, The Museum of Modern Art, 1946.
"Statement by Picasso: 1923," pp. 270–271, originally published by Marius de Zayas as "Picasso speaks," *The Arts* (New York) May 1923. "Statement by Picasso: 1935" originally published by Christian Zervos as "Conversation avec Picasso," *Cahiers d'Art* (Paris), v. 10, no. 10, pp. 173–178, 1935. Translation based on one by Myfanwy Evans in his *The Painter's Object* (London, Gerald Howe, 1937); reprint: New York, Arno Press, 1970.

BARR, ALFRED H., JR., 1947
2. Barr, Alfred H., Jr., & Others. *Symposium on "Guernica."* New York, The Museum of Modern Art, 1947.

Typescript of auditorium event, November 25. Participants: Barr (Chairman), José L. Sert, Jerome Seckler, Juan Larrea, Jacques Lipchitz, Stuart Davis. Reports audience questions and reactions.

BELL, CLIVE, 1936
3. Bell, Clive. Picasso's mind. *New Statesmen and Nation* (London) May 30, 1936, pp. 857–858.
Reprinted: *Living Age* August 1936, pp. 532–534.

BEYELER, ERNST, 1968
4. Beyeler, Ernst, Galerie. *Picasso.* Propos de Pablo Picasso. Préface d'Alfred H. Barr, Jr. Commentaires de Roland Penrose. Basel, Éditions Beyeler, 1968.
Includes text from "Picasso, Fifty Years of His Art" (Barr), "La Vie et l'Oeuvre de Picasso" (Penrose). Works mentioned were included in 85th anniversary shows (November 1966, May 1967), 85 col. pl., 56 ill. Chronology, bibliography, "sources des propos."

BRASSAÏ, GYULA H., 1966
5. Brassaï, Gyula Halász. *Picasso and Company.* New York, Doubleday, 1966.
Preface by Henry Miller; introduction by Roland Penrose. Translated by Francis Price from "Conversations avec Picasso" (Paris, Gallimard, 1964).

CELA, CAMILO JOSÉ, 1960
6. Cela, Camilo José. El viejo picador. *Papeles de Son Armadans* (Valencia), v. 17, no. 49, April 1960.

COCTEAU, JEAN, 1956
7. Cocteau, Jean. *The Journals of Jean Cocteau.* Edited and translated by Wallace Fowlie. New York, Criterion Books, 1956.
Numerous references to Picasso.

COOPER, DOUGLAS, 1958
8. Cooper, Douglas. *Picasso: Carnet Catalan.* Préface et notes par Douglas Cooper. Paris, Berggruen, 1958.
Two parts boxed, including facsimile of small sketchbook and separate commentary.

COOPER, DOUGLAS, 1968
9. Cooper, Douglas. *Picasso Theatre.* New York, Harry N. Abrams, 1968.
Also Paris, Éditions Cercle d'Art, 1967.

DEL POMAR, FELIPE COSSIO, 1932
10. Del Pomar, Felipe Cossio. *Con las Buscadores del Camino.* Madrid, Ediciones Ulises, 1932.

DE ZAYAS, MARIUS, 1923
11. De Zayas, Marius. Picasso speaks. *The Arts* (New York) v. 3, pp. 315–326, May 1923.
Reprinted in Barr (bibl. 1) with comment.

DOMINGUIN, LOUIS MIGUEL, 1961
12. Dominguin, Louis Miguel. *Pablo Picasso: Toros y Toreros.* New York, Abrams, 1961.
Preface by Georges Boudaille; translation by Edouard Roditi.

DUNCAN, DAVID DOUGLAS, 1961
13. Duncan, David Douglas. *Picasso's Picassos.* New York, Harper & Brothers, 1961.

ELUARD, PAUL, 1944
14. Eluard, Paul. *A Pablo Picasso.* Geneva-Paris, Éditions des Trois Collines, 1944.
American edition: *Pablo Picasso.* Translated by Joseph T. Shipley. New York, Philosophical Library, 1947.

FELS, FLORENT, 1925
15. Fels, Florent. *Propos d'Artistes.* Paris, La Renaissance du Livre, 1925.

FERRAN, ANGEL, 1926
16. Ferran, Angel. [Interview]. *La Publicitat,* October 19, 1926.

GALLEGO MORELL, ANTONIO, 1958
17. Gallego Morell, Antonio. Encuentro con Pablo Picasso en Cannes. *Insula,* no. 134, p. 3, January 1958.
Quoted in Gaya Nuño, bibl. 19, p. 206.

GASSER, MANUEL, 1958
18. Gasser, Manuel. Picasso Tauromaco. *Du* (Zurich) August 1958, pp. 11–24.

GAYA NUÑO, JUAN ANTONIO, 1966
19. Gaya Nuño, Juan Antonio. *Bibliografía crítica y antológica de Picasso.* San Juan, Ediciones de la Torre, Universidad de Puerto Rico, 1966.
Text, pp. 7–129. Bibliography, pp. 133–349. Plates (32). Alphabetical citations for books, chapters, catalogues, and articles comprise nos. 1—1, 570, supplemented by illustrated books, nos. 1, 571—1, 644. Comprehensive, rather than exhaustive, with occasional misprints.

GEORGES-MICHEL, MICHEL, 1954
20. Georges-Michel, Michel. De Renoir à Picasso. Paris, Librairie Fayard, 1954.
English edition: Cambridge, Mass., Houghton Mifflin, 1957.

GILOT, FRANÇOISE, 1964
21. Gilot, Françoise, & Lake, Carleton. *Life with Picasso.* New York, Toronto, London, McGraw-Hill Company, 1964.
Not employed in this anthology. For commentary, see pp. xxvi–xxvii.

GIMÉNEZ CABALLERO, ERNESTO, 1935
22. Giménez Caballero, Ernesto. El "expediente" Picasso. *In* Arte y Estado. Madrid, 1935, pp. 43–49.
An interview in San Sebastián during 1934.

GONZALES, JULIO, 1936
23. Gonzales, Julio. Picasso sculpteur. *Cahiers d'Art* (Paris) v. 11, no. 6–7, p. 189, 1936.

GONZALEZ, XAVIER, 1944
24. Gonzalez, Xavier. Notes from Picasso's studio. *New Masses* (New York) v. 53. no. 12, pp. 24–26, December 19, 1944.

GUTTUSO, RENATO, 1964
25. Guttuso, Renato. Journals. Quoted in Mario De Micheli, bibl. 42.

HAESAERTS, PAUL, 1961
26. Haesaerts, Paul, Picasso devant la camera. *Arts* (Paris) no. 312, p. 7, May 25, 1961.

JAKOVSKY, ANATOLE, 1946
27. Jakovsky, Anatole. Midis avec Picasso. *Arts de France* (Paris) no. 6, pp. 3–12, 1946.

JUNYENT, ALBERT, 1934
28. Junyent, Albert. Una visita a Picasso, senyor feudal. *Mirador* (Barcelona) v. 6, no. 288, p. 7, August 9, 1934.
Interview continued in no. 289, p. 7 (August 16). Cited in bibl. 19.

KAHNWEILER, DANIEL-HENRY, 1946
29. Kahnweiler, Daniel-Henry. *Juan Gris: sa vie, son oeuvre, ses écrits.* Paris, Gallimard, 1946.
Other editions include: New York, Curt Valentin, 1947.—New York, Abrams, 1969. Bibliographies.

KAHNWEILER, DANIEL-HENRY, 1951
30. Kahnweiler, Daniel-Henry. Le sujet chez Picasso. *Verve* (Paris) nos. 25–26, pp. 1–21, 1951.
In special issue: "Picasso à Vallauris, 1949–1951." Also published as *Picasso at Vallauris* (New York, Reynal, 1959) consisting of original edition and text with prefatory translations, including Kahnweiler: The content of Picasso's art [p. 1–3].

KAHNWEILER, DANIEL-HENRY, 1952
31. Kahnweiler, Daniel-Henry. Huit entretiens avec Picasso. *Le Point* (Souillac) v. 7, no. 42, pp. 22–30, October 1952.
Dated 1933–1952, with preface. German translation: bibl. 36, 55.

KAHNWEILER, DANIEL-HENRY, 1955
32. Kahnweiler, Daniel-Henry. Du temps que les cubistes étaient jeunes: un entretien au magnétophon [par Georges Bernier]. *L'Oeil* (Paris) no. 1, pp. 26–31, January 15, 1955.

KAHNWEILER, DANIEL-HENRY, 1955A
33. Kahnweiler, Daniel-Henry. Entretiens avec Picasso au sujet des "Femmes d'Alger." *Aujourd'hui* (Boulogne s. Seine) v. 4, pp. 12–13, September 1955.

KAHNWEILER, DANIEL-HENRY, 1956
34. Kahnweiler, Daniel-Henry. Entretiens avec Picasso. *Quadrum* (Brussels) no. 2, pp. 73–76, November 1956.
Six memoirs, 1933, 1935, 1948. English summary, p. 218.

KAHNWEILER, DANIEL-HENRY, 1957
35. Kahnweiler, Daniel-Henry. Picasso: "Ours is the only real painting." *The Observer* (London) pp. 8–9, December 8, 1957.
"Voice of the artist—3" . . . "conversations with Picasso."

KAHNWEILER, DANIEL-HENRY, 1959
36. Kahnweiler, Daniel-Henry. Gespräche mit Picasso. *In* Jahresring 59–60. Stuttgart, Deutsche Verlags Ausstalt, 1959, pp. 85–98.
Seventeen conversations, 1933–1959.

KAHNWEILER, DANIEL-HENRY, 1961
37. Kahnweiler, Daniel-Henry. *My Galleries and Painters* . . . with Francis Crémieux. Translated from the French by Helen Weaver with an Introduction by John Russell. New York, The Viking Press, 1971. Page numbers refer to this edition, originally published as *Mes Galeries et Mes Peintres: Entretiens avec Francis Crémieux*. (Paris, Gallimard, 1971). Viking edition includes detailed bibliography of Kahnweiler's writings by B. Karpel, indicating multilingual sources.

LARREA, JUAN, 1947
38. Larrea, Juan. *Guernica—Pablo Picasso.* New York, Curt Valentin, 1947.
Analytical essays titled "The Vision of the *Guernica.*" Translated by Alexander H. Krappe, edited by Walter Pach, introduction by Alfred H. Barr, Jr., 104 illustrations. Documentation by Dorothy Simmons from bibl. 1.

LEIRIS, MICHEL, 1961
39. Leiris, Michel. *Nuits sans nuit.* Paris, Gallimard, 1961.

LIBERMAN, ALEXANDER, 1956
40. Liberman, Alexander. Picasso. *Vogue* (New York) November 1, 1956, pp. 132–134 ff.

MCCAUSLAND, ELIZABETH, 1944
41. McCausland, Elizabeth. *Picasso.* New York, ACA Gallery, 1944. (ACA Publications 1).
Reprints reviews from *The Springfield Republican* (Mass.) 1933–44, translation of "The Dreams and Lies of France," "Picasso's statement" (1937), p. 21 and "Picasso to America" (1937), pp. 23–24.

DE MICHELI, MARIO, 1964
42. De Micheli, Mario. *Scritti di Picasso.* Milan, Feltrinelli, 1964.
Includes extracts, e.g. Guttuso (bibl. 25), Kahnweiler (bibl. 34), and Trombadori (bibl. 79).

DER MONAT, 1949
43. [Clipping on Picasso]. *Der Monat* (Berlin) December 1949.

NEW YORK TIMES, 1937
44. Picasso to America. *New York Times*, December 19, 1937.
Quoted in McCausland (bibl. 41, pp. 23–24), Barr (bibl. 1, p. 264).

PARMELIN, HÉLÈNE, 1963
45. Parmelin, Hélène. *Picasso Plain*. London, Secker & Warburg, 1963.
Translation: *Picasso sur la place*. Paris, Julliard, 1959.

PARMELIN, HÉLÈNE, 1964
46. Parmelin, Hélène. *Picasso: Women. Cannes and Mougins, 1954–63*.
New York, Time-Life, 1964; London, Weidenfeld, 1965.
Translated from the French: Paris, Cercle d'Art, 1964.

PARMELIN, HÉLÈNE, 1965
47. Parmelin, Hélène. *Picasso: the Artist and His Model, and Other Recent Works*. New York, Abrams, 1965.
Translated from the French: Paris, Cercle d'Art, 1965.

PARMELIN, HÉLÈNE, 1966
48. Parmelin, Hélène, *Intimate Secrets of a Studio at Notre Dame de Vie*. New York, Abrams, 1966.
Translated from the French series issued by Éditions Cercle d'Art as "Secrets d'alcôve d'un atelier" (3 vol.), 1964–1965.

PARMELIN, HÉLÈNE, 1969
49. Parmelin, Hélène. *Picasso says* . . . London, Allen and Unwin, 1969.
Translated by Christine Trollope from *Picasso dit* . . . (Paris, Gonthier, 1966), which incorporated parts of her *Secrets d'alcôve d'un atelier*.

PARROT, LOUIS, 1948
50. Parrot, Louis. Picasso at work. *Masses and Mainstream* (New York) pp. 6–20, March 1948.

PENROSE, ROLAND, 1951
51. Penrose, Roland, ed. *Homage to Picasso on His 70th Birthday*. Drawings and Water colours since 1893. London, Lund Humphries, 1951.
Issued in collaboration with the Institute of Contemporary Arts on the exhibition. Essay by Penrose: "Drawings of Picasso"; contribution by Paul Eluard: "Picasso good master of liberty" (English and French).

PENROSE, ROLAND, 1958
52. Penrose, Roland. *Picasso: His Life and Work*. London, Gollancz, 1958.
American edition: New York, Schocken Books, 1962.

PENROSE, ROLAND, 1967
53. Penrose, Roland. *The Sculpture of Picasso*. New York, The Museum of Modern Art, 1967.
Chronology by Alicia Legg; bibliography by Inga Forslund; catalogue of the exhibition.

PICASSO, PABLO, 1937
54. Picasso, Pablo. Statement (1937). *In* McCausland (bibl. 41, p. 21), Barr (bibl. 1, pp. 202, 264).
"Translated by Elizabeth McCausland."

PICASSO, PABLO, 1954
55. Picasso, Pablo. *Wort und Bekenntnis.* Die gesammelten Dichtungen und Zeugnisse. Neue, erweiterte Ausgabe. Zurich, Verlag der Arche, 1954.
The second edition of nine translations is supplemented by essays on Picasso from Nikolai Berdiajew (1914) and C. G. Jung (1932). Includes Kahnweiler (bibl. 31).

PONGE, FRANCIS, 1960
56. Ponge, Francis. *Dessins de Pablo Picasso: Époques bleue et rose.* Lausanne, Mermod, 1960.
With letter by Ponge and biography by Jacques Chessex.

PREJER, LIONEL, 1961
57. Prejer, Lionel. Picasso découpe le fer. *L'Oeil* (Paris) no. 82, pp. 28–33, October 1961.

PUDNEY, JOHN, 1944
58. Pudney, John. Picasso—a glimpse in sunlight. *New Statesman and Nation* (London) v. 28, no. 708, pp. 182-183, September 16, 1944.
Also quoted in part in "Picasso 1940–1944—a digest with notes by Alfred H. Barr, Jr." *Museum of Modern Art Bulletin* (New York) v. 12, no. 3, pp. 5–6, January 1945.

RICHARDSON, JOHN, 1962
59. Richardson, John. Understanding the paintings of Pablo Picasso. *The Age* (London) December 22, 1962,
"The first of two articles."

RÖNNEBECK, ARNOLD, 1944
60. Rönnebeck, Arnold. *Books Abroad* (Norman, Okla.) v. 19, pp. 2–7, January 1945.

ROTHENSTEIN, SIR JOHN, 1945
61. Rothenstein, Sir John. A letter on Paris. *Cornhill Magazine* (London) 1964, pp. 288–295.
Dated April 1945.

ROY, CLAUDE, 1956
62. Roy, Claude. *L'Amour de la peinture: Goya, Picasso et autres peintres.* Paris, Gallimard, 1956.

RUBIN, WILLIAM, 1972
63. Rubin, William. *Picasso in the Collection of the Museum of Modern Art.* New York, The Museum of Modern Art, 1972.

SABARTÉS, JAIME, 1946
63a. Sabartés, Jaime. *Picasso: portraits et souvenirs.* Paris, Louis Carré & Maximilien Vox, 1946.
Translation by Angel Flores: *Picasso: an Intimate Portrait.* New York, Prentice-Hall, 1948.

SABARTÉS, JAIME, 1948
64. *Picasso à Antibes.* Photographies de Michel Sima; commentées par Paul Eluard; introduction par Jaime Sabartés. Paris, René Drouin, 1948.

SABARTÉS, JAIME, 1954
65. Sabartés, Jaime. *Picasso, documents iconographiques.* Geneva, Cailler, 1954.
Preface and notes by Sabartés; translation by F. Leal and A. Rosset.
Another work translated from the Spanish (not quoted): *Picasso: portraits et souvenirs.* Paris, Louis Carré & Maximilien Vox, 1946.

SALAS, XAVIER DE, 1960
66. Salas, Xavier de. Some notes on a letter of Picasso. *Burlington Magazine* (London) pp. 482–484, November 1960.
Dated Madrid, November 3, 1897. Partially published in the recent Picasso catalogue, O'Hana Gallery (June 23–July 28, 1960).

SALLES, GEORGE, 1964
67. Salles, George. Histoire d'un portrait. *In* Pour Daniel-Henry Kahnweiler. New York, Wittenborn, 1965, pp. 268–273.
Direction: Werner Spes. Copyright: Verlag Gerd Hatje, Stuttgart.

SALMON, ANDRÉ, 1956
68. Salmon, André. *Souvenirs sans fin.* Paris, Gallimard, 1956.
Première époque (1903–1908).—deuxième époque (1908–1920).

SECKLER, JEROME, 1945
69. Seckler, Jerome. Picasso explains. *New Masses* (New York) pp. 4–7, March 13, 1945.

SOUCHÈRE, DOR DE LA, 1960
70. Souchère, Dor de la. *Picasso in Antibes.* Official catalogue of the Musée d'Antibes known as the Musée Picasso. New York, Pantheon, 1960.
Translated by W. J. Strachan from the French: *Picasso à Antibes.* Paris, Hazan, 1960.

SPENDER, STEPHEN, 1946
71. Spender, Stephen. Keeping a great city alive. *Vogue* (New York), December 1946, pp. 194, 224, 226.

DER SPIEGEL, 1956
72. Picasso. *Der Spiegel* (Munich) no. 52, December 1956.

STEIN, GERTRUDE, 1933
73. Stein, Gertrude. *The Autobiography of Alice B. Toklas.* New York, Harcourt Brace, 1933.
Page numbers refer to current "Modern Library" edition (New York, Random House).

STEIN, GERTRUDE, 1959
74. Stein, Gertrude. *Picasso.* Boston, Beacon Press, 1959.
Other editions: Paris, Librairie Floury, 1938.—New York, Scribner, 1938.—London, Batsford, 1939.—Buenos Aires, Schapire, 1954.—Zurich, Die Arche, 1958. Supplemental data in: *Gertrude Stein on Picasso.* New York, Liveright in cooperation with the Museum of Modern Art, 1970.

SZITTYA, EMILE, 1947
75. Szittya, Emile. *Notes sur Picasso*. Paris, Courrier des Arts et des Lettres, 1947 (Portrait No. 1).

TÉRIADE, E., 1932
76. Tériade, E. En causant avec Picasso. *Intransigeant* (Paris) June 15, 1932.
Reprinted in *Verve* (Paris) nos. 19-20, 1948 as "Propos de Picasso à Tériade."

TÉRIADE, E., 1933
77. Tériade, E. Émancipation de la peinture. *Minotaure* (Paris) Nos. 3-4, p. 13, December 1933.

TÉRY, SIMONE, 1945
78. Téry, Simone. Picasso n'est pas officier dans l'Armée française. *Les Lettres Françaises* March 24, 1945.
Reprinted in Barr (bibl. 1), pp. 357-358 (English), 269 (French).

TROMBADORI, ANTONELLO, 1964
79. Trombadori, Antonello. Parlo con la pittura. Quoted in Mario De Micheli (bibl. 42).

VALLENTIN, ANTONINA, 1957
80. Vallentin, Antonina. *Pablo Picasso*. Paris, Club des Éditeurs, Albin-Michel, 1957.

VERDET, ANDRÉ, 1963
81. Verdet, André. *Picasso*. Geneva, Musée de l'Athenée, 1963.
Prefatory text by Verdet to exhibition held July–September 21.

WARNOD, ANDRÉ, 1945
82. Warnod, André. En peinture tout n'est que signe, nous dit Picasso. *Arts* (Paris) no. 22, pp. 1, 4, June 29, 1945.
English extract in Barr (bibl. 1), p. 241.

ZERVOS, CHRISTIAN, 1932
83. Zervos, Christian. *Pablo Picasso, Vol. 1: Oeuvres de 1895 à 1906*. Paris, Éditions "Cahiers d'Art," 1932.
Also reprints, e.g. 3rd ed., 1957.

ZERVOS, CHRISTIAN, 1935
84. Zervos, Christian. Conversation avec Picasso. *Cahiers d'Art* (Paris) v. 10, pp. 173-178, 1935.
English translation published in Barr (bibl. 1, pp. 272-274) as "Statement by Picasso: 1935." It is "based" on one by Myfanwy Evans in his *The Painter's Object* (London, Howe, 1937), pp. 81-88. Reprinted *Creative Art* June 1930, pp. 383-385; *Picasso 2 Statements* (New York & Los Angeles, Merle Armitage, 1963) and elsewhere.

Illustrations

37 *Dans l'atelier*, ink drawing, December 25, 1953 (Zervos 16, no. 86)
39 Notebook page, pencil drawing, 1940 (Zervos 10, no. 174)
41 *Le Peintre et son modèle nu*, ink drawing, 1942 (Zervos 12, no. 159)
44 *Peintre et modèle*, ink drawing, January 10, 1954 (Zervos 16, no. 171)
46 *Dans l'atelier*, ink drawing, January 10, 1954 (Zervos 16, no. 175)
47 Pencil drawing, February 5, 1935 (Zervos 8, no. 249)
50 Drawing in the Eluard edition, Honoré de Balzac's *Le Chef d'oeuvre inconnu* (Paris, Vollard, 1944, Collection Mr. and Mrs. Arthur A. Cohen, New York)
52 *Les Masques*, ink drawing, January 24, 1954 (Zervos 16, no. 222)
55 *Composition*, pencil drawing, February 5, 1935 (Zervos 8, no. 248)
57 *Peintre et modèle*, ink drawing, January 10, 1954 (Zervos 16, no. 173)
61 Illustration for Honoré de Balzac's *Le Chef d'oeuvre inconnu* (Paris, Vollard, 1944, Collection Mr. and Mrs. Arthur A. Cohen, New York)
62 Illustration for Honoré de Balzac's *Le Chef d'oeuvre inconnu* (Paris, Vollard, 1944, Collection Mr. and Mrs. Arthur A. Cohen, New York)
65 *Peintre et modèle*, ink drawing, December 24, 1953 (Zervos 16, no. 73)
67 *L'Atelier*, pencil drawing, February 22, 1933 (Zervos 8, no. 92)
68 Illustration for Paul Eluard's *À Pablo Picasso* (Geneva, Trois Collines, 1944)
70 First page from a notebook, March 4, 1940 (Zervos 10, no. 378)
71 Untitled ink drawing, September 19, 1941 (Zervos 11, no. 306)
74 Drawings in Honoré de Balzac's *Le Chef d'oeuvre inconnu,* Eluard edition (Paris, Vollard, 1944, Collection Mr. and Mrs. Arthur A. Cohen, New York)
77 Drawing in Honoré de Balzac's *Le Chef d'oeuvre inconnu,* Eluard edition (Paris, Vollard, 1944, Collection Mr. and Mrs. Arthur A. Cohen, New York)
78 *Homme couché et femme assise*, ink drawing, December 16, 1942 (Zervos 12, no. 195)
83 *Deux femmes nues*, pencil drawing on Japanese paper, June 8, 1961 (Zervos 20, no. 31)
85 *Artist and Model*, lithograph, 1954 (Collection The Museum of Modern Art, New York. Gift of Mr. and Mrs. E. Powis Jones)
87 Illustration for Honoré de Balzac's *Le Chef d'oeuvre inconnu* (Paris, Vollard, 1944, Collection Mr. and Mrs. Arthur A. Cohen, New York); wood engraving by Aubert after drawing by Picasso

11-2-41